Cartooning Made Easy

CIRCLE, TRIANGLE, SQUARE

Margherita Cole

Brimming with creative inspiration, how-to projects, and useful information to enrich your everyday life, quarto.com is a favorite destination for those pursuing their interests and passions.

First published in 2022 by Walter Foster Publishing, an imprint of The Quarto Group.
100 Cummings Center, Suite 265D, Beverly, MA 01915, USA.
T (978) 282-9590 **F** (978) 283-2742 **www.quarto.com** • **www.walterfoster.com**

Walter Foster Publishing titles are also available at discount for retail, wholesale, promotional, and bulk purchase. For details, contact the Special Sales Manager by email at specialsales@quarto.com or by mail at The Quarto Group, Attn: Special Sales Manager, 100 Cummings Center, Suite 265D, Beverly, MA 01915, USA.

ISBN: 978-0-7603-7729-1

Digital edition published in 2022
eISBN: 978-0-7603-7730-7

Printed in China
10 9 8 7 6 5 4 3 2 1

Table of Contents

Introduction

Are you ready to begin your cartooning journey? This field of art is full of possibilities, so you're sure to have fun. From eccentric comic strips to imaginative manga and exciting animated shows, you've likely come across many different forms of cartoons. But even all these genres have some things in common!

Instead of focusing on the details, cartooning is a type of art that tries to capture the essence of something. This simplification is what creates lovable characters that are cute, funny, and sometimes scary. You can really do whatever you want in cartooning, which is what makes it so fun to explore.

Although there's a lot to learn, this book attempts to make the process easier by showing you how circles, triangles, and squares can help you make unique cartoon characters, animals, and even objects. So, what are you waiting for? Turn the page to start your adventure!

Tools & Materials

There is a wide range of tools and materials available for cartooning and illustration. With so many options, it's a good idea to explore and experiment to discover which you like the best! Below are some good choices to start with.

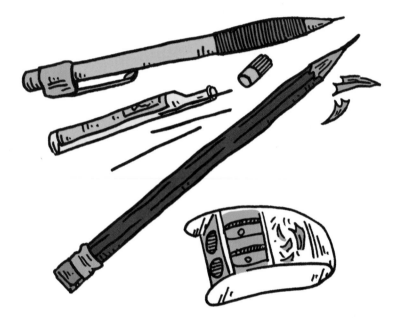

PENCILS

A pencil is a must-have in drawing. Choosing the right one, however, might take some experimenting. Mechanical pencils are available in different lead thicknesses, such as 0.7 and 0.5, and are refillable. They are ideal for artists who desire precision in their linework, as well as in illustrations that require a lot of detail. On the other hand, traditional wooden pencils are irreplaceable in sketching. Depending on which hardness you choose (HB, B, or 2B), these utensils will help you draw quickly and expressively.

ERASERS

While your pencil will often include an eraser at the other end, it's best not to depend on this eraser alone. Instead, keep a large white rubber eraser on hand.

PENS

Cartooning typically features bold, black lines, so you'll want to collect a nice variety of pens to use in your art. While there are many you can use, these types are most commonly used in cartooning:

- **Fine liners:** With a fast drying time and a range of nib widths, these are perhaps the most straightforward pens to use in your drawing. You can trust that these will create consistent, even line work.

- **Brush pens:** As its name suggests, this type of pen has a brushlike feel to it. This means that the more pressure you place on the brush, the thicker your lines will be, but if you apply very light pressure, you can make much finer lines. Brush pens are great for bold and expressive lines.

- **Dip pens:** While these are less common now, dip pens used to be the standard tool for cartoonists and illustrators. Instead of containing ink inside the body of the pen, this utensil requires the artist to repeatedly dip the metal nib into an ink reservoir. It's a more meticulous process, but the benefit of using it is a range of line thicknesses.

ADDING COLOR

Cartoons don't require any color, but if you want to add some pigments to your drawing, there are many easy ways to do it.

- **Colored pencils:** If you're comfortable using a pencil, colored pencils are a natural next step. By layering a couple of different colors, you'll be able to create depth. Similarly, you can sharpen these utensils to outline your sketches.

- **Markers:** This is probably the most popular way of coloring cartoons and manga today, and it's easy to understand why. With just one layer, you can create vibrant colors to match the boldness of your linework.

PAPER

There's an array of paper out there, but depending on whether you're sketching or making finished artwork, you'll probably want a certain kind to work with. Here are some options.

- **Drawing paper:** You can use just about any kind of paper for drawing, but if you're practicing techniques or sketching ideas, there's no need to invest in an expensive kind. Printer paper or an inexpensive sketch pad will suit your needs just fine.

- **Sketchbooks:** To document your artistic progress and store your ideas in one place, keep a sketchbook. Most sketchbooks contain normal drawing paper, which is better suited for pencil and pen and not ideal for wet media.

- **Bristol paper:** Bristol paper is a stiff type of paper that is very popular in comics and illustration. The smooth texture is best for pencil, pen and ink, and markers, whereas the vellum surface (which has more "grip," or texture) is preferred for graphite, colored pencil, and pastel.

RULERS & OTHER MATERIALS

In addition to the basic drawing supplies we've already discussed, you may want a few accessories to make things easier. A basic ruler will help you render straight lines and create borders around your illustrations. It's also useful if you want to make panels for comic strips. Similarly, a compass or stencil can help you draw perfect circles.

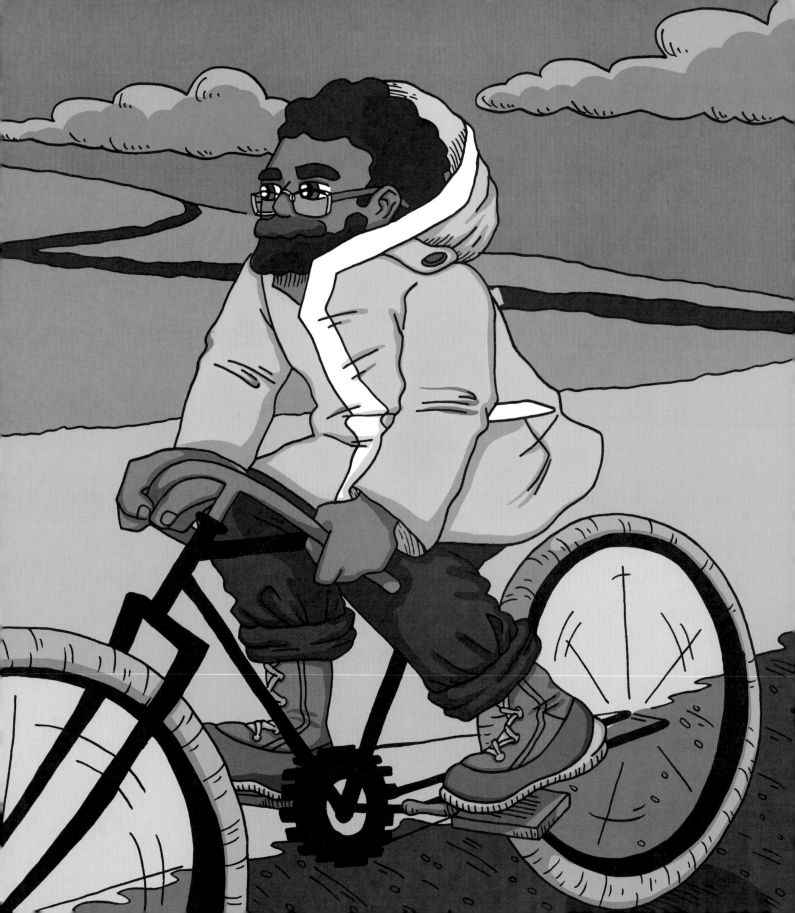

CHAPTER ONE:
Shapes Are Everywhere!

One of the first things we're taught as children is how to identify shapes. Now, as an artist, you need to learn this skill again—only this time, you need to be able to find shapes in the world around you. This will make drawing subjects—any type of subject, really—much, much easier.

Does this sound difficult? It's actually pretty straightforward! In fact, you can probably find shapes wherever you are right now. A rectangular door, for instance. A circular clock. A square picture frame. The list goes on and on.

These are some of the more obvious ones. The truth is that even organic things, like trees and trees, tigers, and yes, people, can be broken into shapes. You just need to learn what to look for.

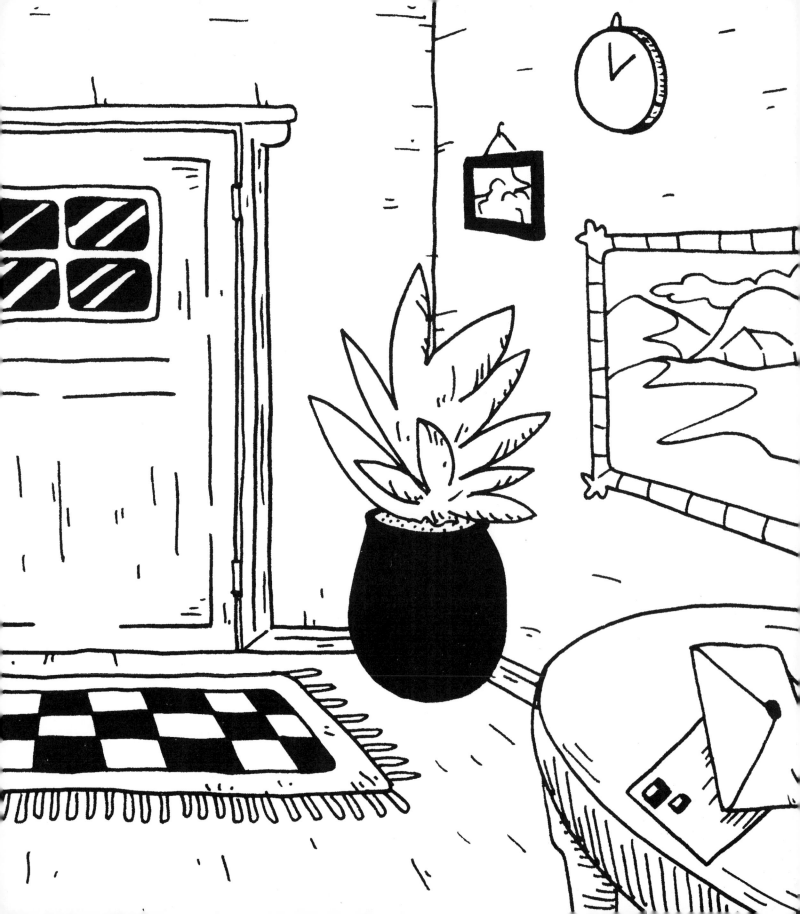

Drawing Shapes
(and Why You Should Do It)

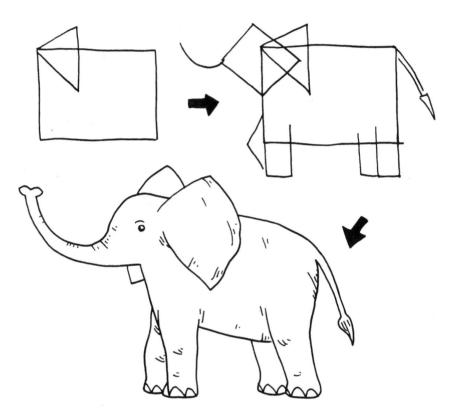

OK, even if we can find shapes in everyday objects and animals, why do we need them in drawing? The answer is quite simple, really: shapes help you draw. Here are just a couple of things shapes can help with:

- **Getting started:** Imagine you're drawing an elephant. Such a large animal can be overwhelming if you don't know where to start. By breaking it up into a rectangular body, rectangular legs, and so on, you make it a gradual, step-by-step process, thereby removing some of the hesitations.

- **Proportions:** Regardless of what the subject is, it's difficult to translate size accurately on paper. Shapes can help you create a basic framework so that it's easier to measure proportions.

- **Efficiency:** This goes hand in hand with the first bullet points, but shapes will make your drawing process dramatically more efficient. Instead of struggling with sketching a subject line by line and taking a long time to get it the way you want, drawing shapes will cut that time in half.

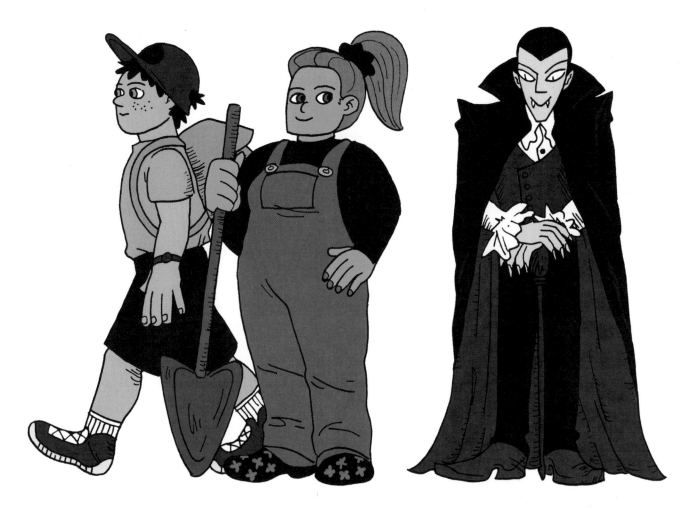

SHAPES & CARTOONS

So, why are shapes important in drawing cartoons, specifically? Well, we already talked about how cartoons capture the essence of something. And since shapes create the foundation of drawings, it only makes sense that these two things—which are both based on simplicity—work harmoniously together. Here are some more reasons why it's important:

- **Personality:** Each shape has a feeling to it. Circles feel softer and younger, and squares have a more rigid impression. Using certain shapes in your cartoons will give your characters a distinct personality.

- **Proportions:** Measuring proportions is just as important in cartoons as it is in realism. The only difference is that in cartoons, you may want to exaggerate certain features, which still comes down to measuring proportions.

- **Style:** The way in which you use shapes will also determine your style. Using mostly round shapes, for instance, will give the impression of a certain style. The same is true if you prefer using other forms in your art.

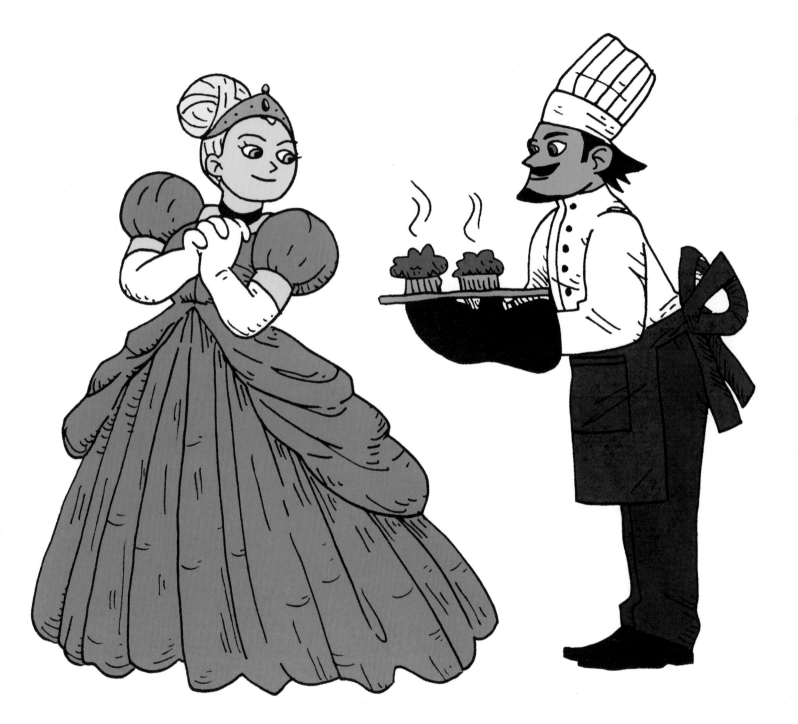

BASIC SHAPES

Ultimately, drawing comes down to three basic shapes—circles, squares, and triangles—and everything you draw can be created by using some combination of these forms. (Ovals and rectangles are just derivatives of circles and squares, respectively.)

Circles and ovals

Squares and rectangles

Triangles

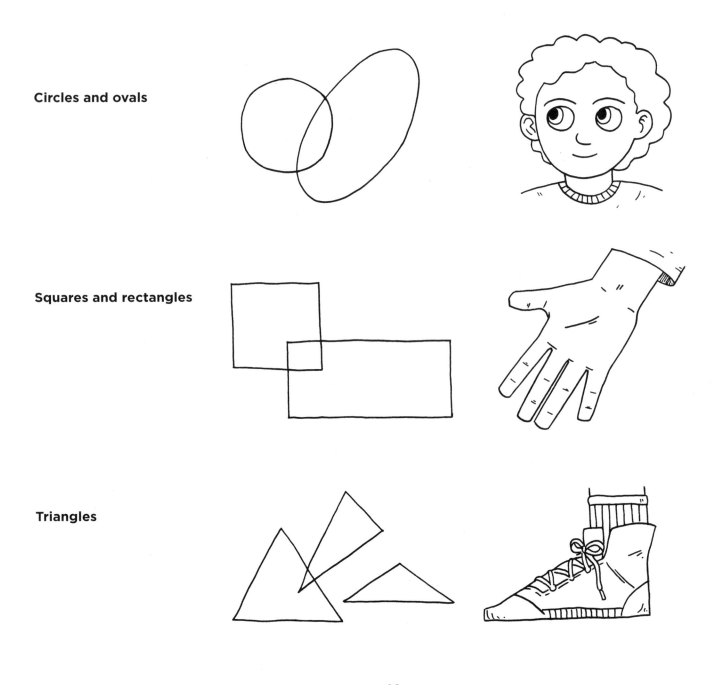

Identifying Shapes in Real Life

Now that we know the basic shapes, try taking another look around you and see if you can find circles, squares, and triangles in your surroundings. Does your cat have triangle-shaped ears, maybe? Or is the tree outside made up of circular clusters of leaves? The key is to find the simplest shape or shapes inside something that is more complicated, so it may take some getting used to.

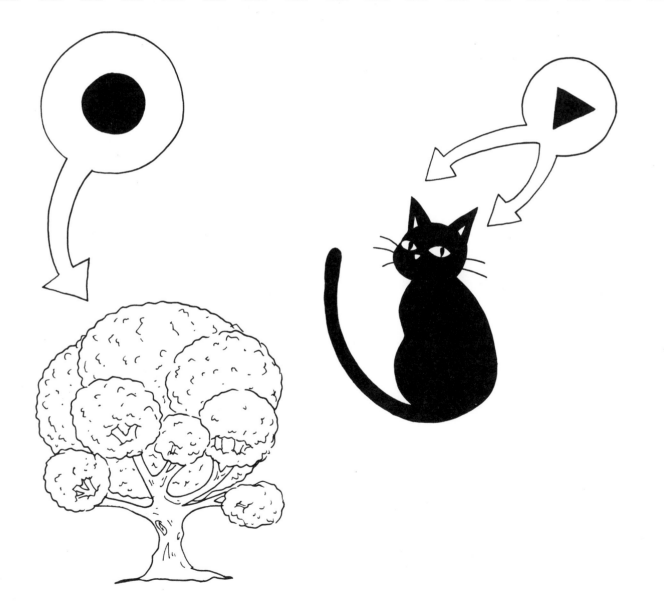

CHAPTER TWO:
What Can You Do with Circles & Ovals?

Have you ever tried to draw a perfect circle? It's not easy, but fortunately, in art, a perfect circle is rarely required. You will, however, have to draw a lot of circles in art, so it's important to get used to sketching them. Circles and ovals are extremely useful, you see, and will be the foundation of most of the people you draw. Let's look at some specific ways we can use them.

Heads

You may hear of face shapes described as oval or circular. Let's use circles and ovals to create heads for our characters to give them a distinct appearance from various angles.

FRONT—FACING HEAD

When drawing a character facing forward, the most important thing to keep in mind is balance. It is literally the most straightforward angle, so any asymmetry will be more apparent. Don't let that discourage you from practicing this angle, however. With practice, you will slowly become accustomed to measuring the proportions of the face.

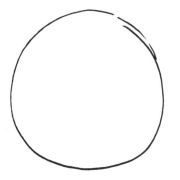

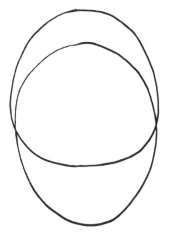

1

Begin by lightly sketching a circle.

2

Add an oval inside the circle, thereby lengthening the head.

3

Find the halfway point of the head and draw round ears on either side.

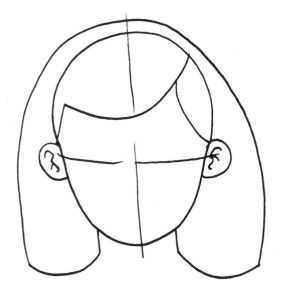

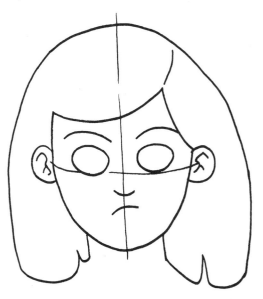

4

Add details if you wish, such as the hairline, and sketch horizontal and vertical guidelines to help you with the facial features.

5

Draw a pair of round eyes along the horizontal line (about halfway down the head), and a nose and mouth below.

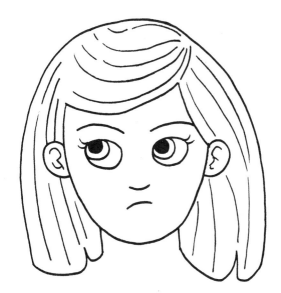

6

All that's left is to fill in the details!

HEAD TO THE SIDE (RIGHT & LEFT)

If you have trouble with proportions, like drawing the dreaded "other eye," then sketching heads from angles will help you hide your mistakes. Unlike heads facing forward, where everything should be more or less bilateral, heads from the side have uneven features. This is due to perspective and the way the human face changes depending on how it is viewed.

To draw a head from this angle, start by sketching a circle and, depending on which angle you want to draw, add an oval slightly to the side of it. Sketch a round ear halfway down the head and draw a short neck at the base of the head. Sketch a horizontal and vertical guideline, and use these marks to help place a pair of eyes halfway down the face and a nose and mouth just below that. Then flesh out the details.

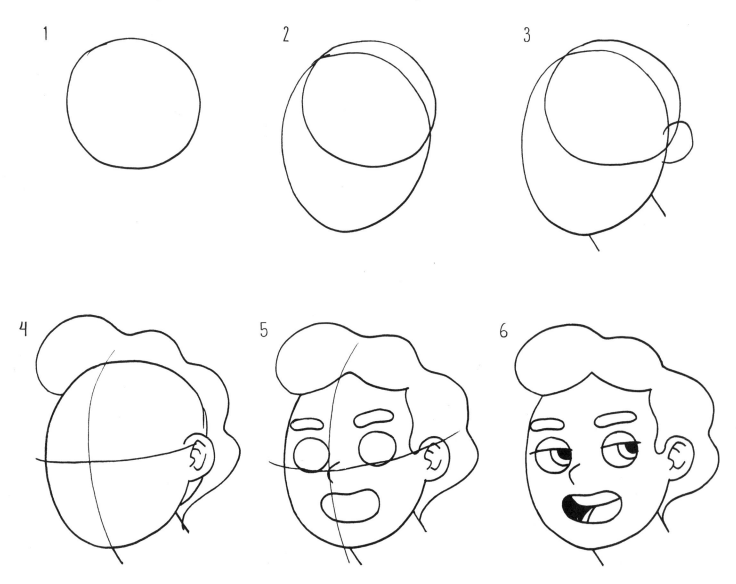

THREE—QUARTER HEAD

Similar to the side angle, the three-quarter is another viewpoint that is forgiving to mistakes. Not only that, but it is also very useful when drawing characters in all kinds of scenarios.

To draw this angle, you once again begin by sketching a circle. Then add a circle or an oval inside the first circle. Draw an ear halfway down the head and add a neck. Then fill out the head with features like the hair, eyes, nose, and mouth. If you're creating a cuter character, keep the eyes at least halfway down the face. Add any remaining details to the head, and you're done!

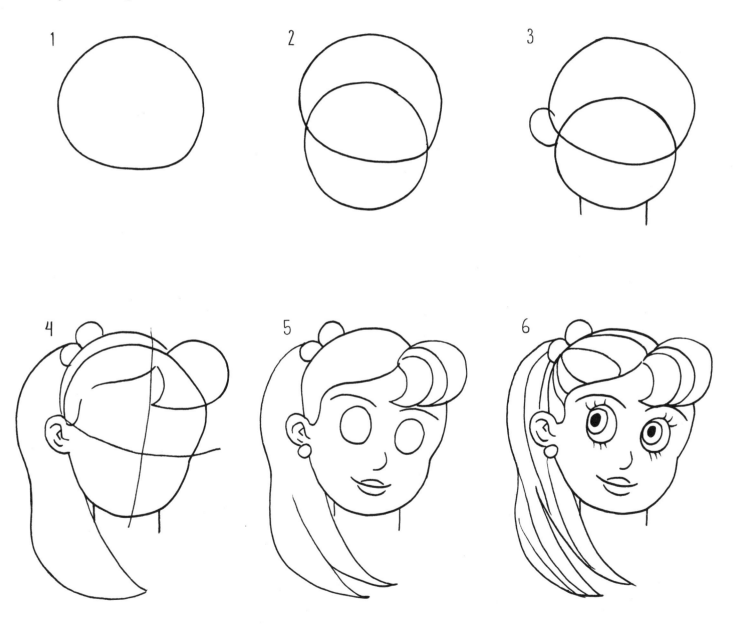

Faces

With a little bit of exaggeration and manipulation, you an easily create a face made entirely of circles and circle-based shapes.

EYES

In real life, we describe eyes as almond or round, but in cartoons, you can stretch a character's eyes to extreme proportions. In doing so, you will make a person cuter, more emotional, or more unique.

Oval Eyes

Oval eyes have a classic cartoon feel to them, and fortunately, making them is pretty straightforward too. All you need to do is sketch one oval, create a space, and sketch the other one. Drawing the other eye is never easy, but you'll find that with practice, you'll get a lot more comfortable.

Once you've drawn the two ovals, you can draw a circle inside to create the iris. Then sketch another circle inside that one to make the pupil. Fill in the pupil with black and add lashes if desired.

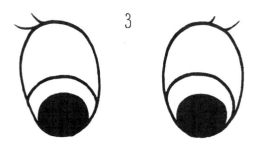

Round Eyes

When in doubt about what eye shape to give your character, you can never go wrong with round eyes. This shape immediately gives the impression of youth and cuteness, so it's a popular eye shape for children, teenagers, and main characters.

To make round eyes, you'll want to draw two circles, with an even space between them. Then add an oval or circle shape inside to make the iris. Afterward, add another circle inside that one to create the pupil. Fill in the pupil with black and add lashes if desired.

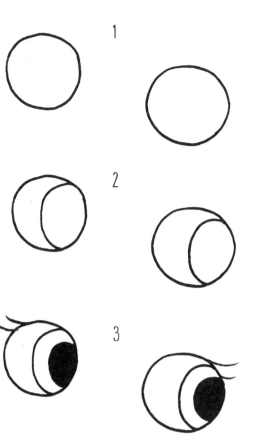

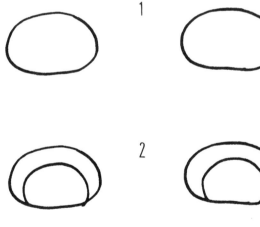

Wobbly Eyes

Now that we've covered the traditional circular eye shapes, we can practice the slightly more unusual ones. Wobbly eyes are oval in shape, but with a slight bend to them, either on the bottom or on the top. They are great shapes for characters feeling an intense emotion.

Draw two ovals horizontally and add a wobble somewhere. Then draw a large circle inside to make the iris. Add another circle inside that one to create the pupil. Fill in the pupil with black and add lashes if desired.

Tilted Oval Eyes

Tilted, oval eyes are also a great choice! This pair, like the wobbly eyes, puts a spin on the classic cartoon eye shape. You're still using the oval, but by sketching it an angle, you'll create an interesting allure to your character's gaze.

So, sketch two ovals at a slight tilt. They should point in the direction of the character's nose. Then add a circle inside to make the iris. Afterward, add another circle to create the pupil. Fill in the pupil with black and add lashes if desired.

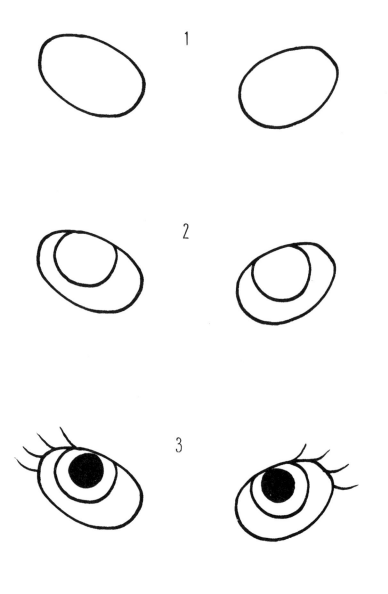

EYEBROWS

Once you've drawn eyes, it's only natural that you'd want to complement them with a pair of eyebrows. And while you can easily create distinct brows with some bold lines, you should consider making them with shapes.

Creating eyebrows with elongated ovals will give a character a distinct appearance. Plus, strong eyebrows are great for expressing emotion in your art. All you have to do is bend the brows in different directions to change your character's mood.

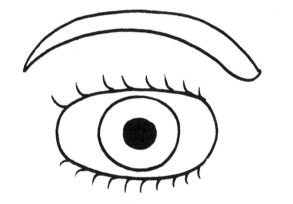

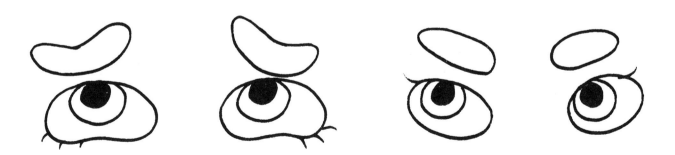

NOSES

While noses may not seem like the most exciting thing to draw, this feature is crucial to your character's face. Whether you decide to sketch a big nose, a tiny nose, a long nose, or a thin nose, the decision will influence the way your character comes across. So, how can you create a nose with circles and ovals?

Well, unlike some of the other features, which require an additive process, you'll be using shapes as a basis from which you will remove a part. For example, if you draw an oval nose in the center of your character's face, you can either leave it as is, or erase half of it until it is almost a backwards L-shape.

Similarly, if you use an oval to draw a nose in profile, you can then erase the part of the oval that cuts into the person's face.

This process also works if you use a circle to create a nose. Simply sketch the circle, choose which part to erase and which to keep, and you're done. It's that easy.

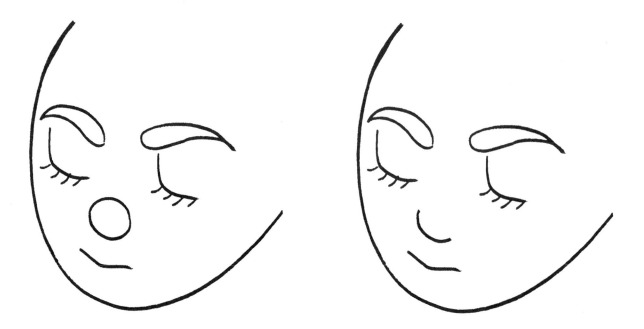

Round Nose

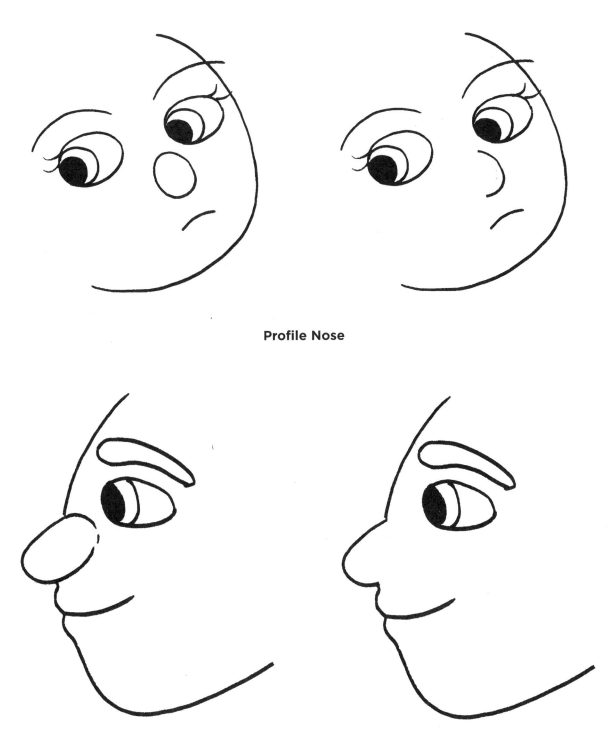

Profile Nose

Oval Nose

MOUTHS

Gasping, talking, yelling...circles and ovals can help you communicate all of these actions on your character's face. Try using variations of this round shape when you render a person's mouth, and see what you can do with it. Although it's simple, the results are surprisingly effective. Just remember to add some teeth and a tongue to give your character's mouth more depth. Just a quick swoop on top and below will do the trick. Then fill in the empty mouth space with black.

As for lips, you can use both ovals and circles to make them. A pair of circles right next to each other will help you make a convincing Cupid's bow, for instance. But two ovals will also easily make a pair of full lips.

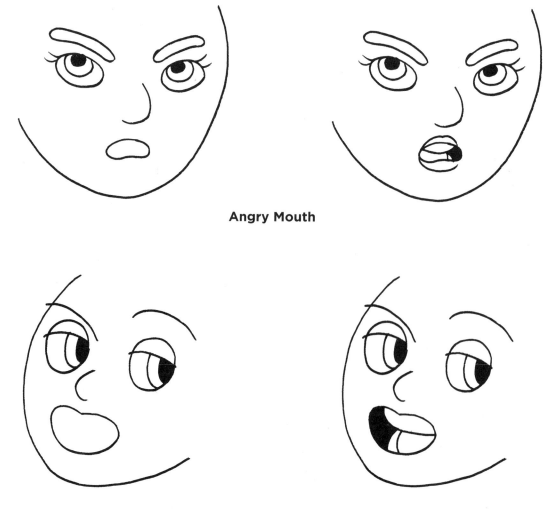

Angry Mouth

Open Mouth

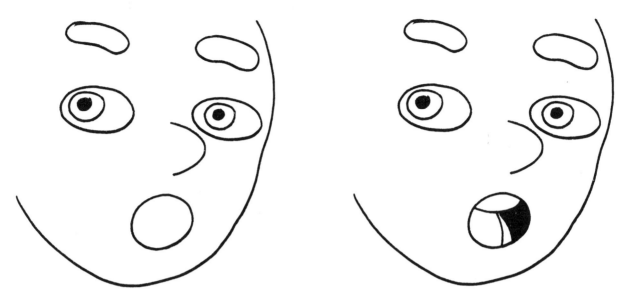

Surprised Mouth

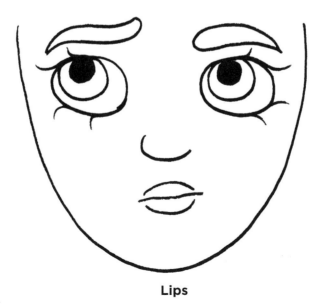

Lips

Hands

Hands say a lot about what a character is doing and how they're feeling. Even if you find hands hard to draw right now, remember that with practice, they will become easier. By using circles and ovals, you will make the process even simpler.

Instead of struggling to find the proportions line by line, try drawing a circle to create the palm and sketching ovals to make the fingers. Once you do that, you're already halfway there! Here are some hand poses to practice.

OPEN HAND

A flat, open hand is a good pose for practicing the anatomy basics. The key is to make sure you draw fingers at the correct length, and double-check that you leave enough room between the first finger and the thumb.

1 2 3 4

OPEN PALM HAND

Here, we'll utilize the same technique as on page 32 to render a hand that is reaching out, with the palm facing the viewer. Once again, you'll arrange the oval-shaped fingers along the circle at the correct spacing—only here, the thumb will be folded over the palm.

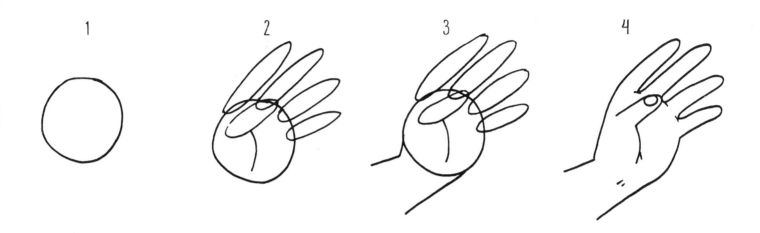

STRETCHED HAND

Drawing a hand that is stretched on a flat surface is another useful pose to master. Here, you'll want to keep the majority of the fingers squeezed together, leaving the pinkie finger slightly to the side, as it tends to do. Draw the thumb slightly lifted as well.

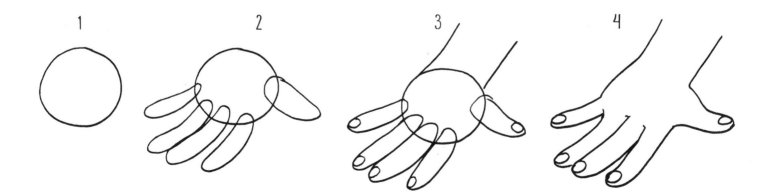

CLENCHED HAND

A clenched hand is a practical pose that does not require you to draw extended fingers. Instead, you will sketch half ovals to indicate that the fingers are closed in the palm. You can keep the thumb on the outside if you wish.

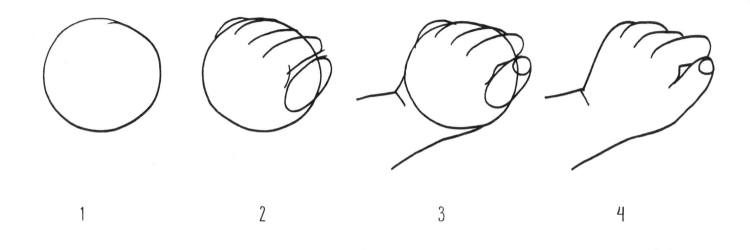

| 1 | 2 | 3 | 4 |

FIST

From holding utensils to punching objects, the fist is another essential hand gesture, and it's much easier to create than you think. Using the circle as the base, add slightly shorter ovals to one side to create the impression of fingers that are folded into the palm. Do the same for the thumb, only bending it over the other fingers. The thumb should remain on the outside of the fist.

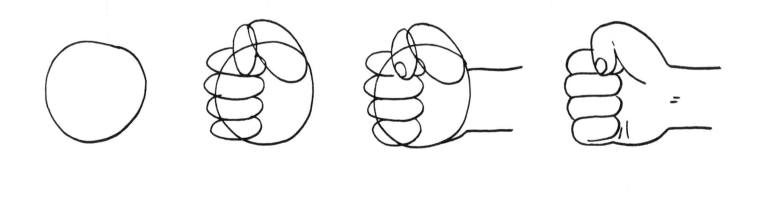

| 1 | 2 | 3 | 4 |

DRAWING HAND

A hand holding a pencil may be one of the more difficult positions to draw, but it's a good one to know, nonetheless. Here, it is crucial that you take your time adding the fingers one by one to ensure you get the placement right. Fortunately, you can always compare your results to your own hand to see how well you did.

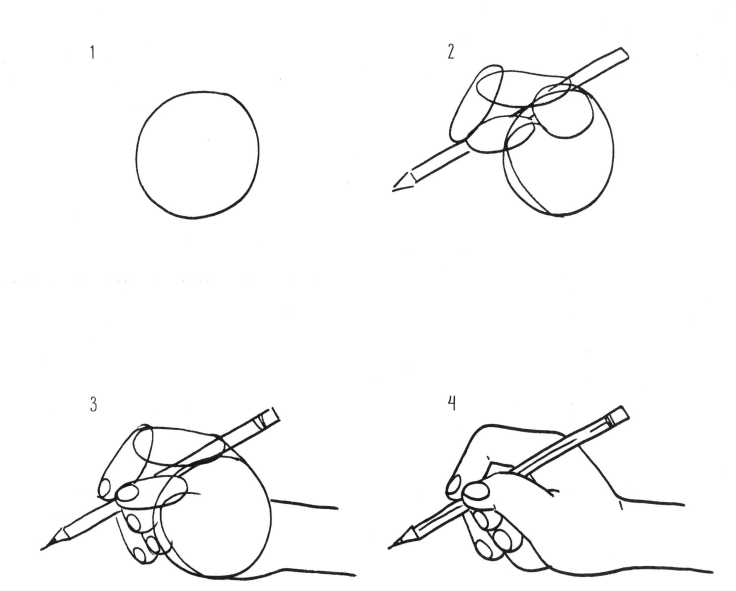

1

2

3

4

Bodies

Circles and ovals are round, which means they will make your characters soft in appearance too. So, depending on what kind of person you want to draw, this can be a great trait to have. Protagonists and younger people, for instance, are two types of characters that benefit greatly from using circles.

Use these basic shapes we've been practicing to create the bodies of a woman, man, and child, and see the different effects they have. The key is to place the circles and ovals in the key areas of the head, torso, and joints to slowly build the desired proportions of your characters. Once you've practiced the basic anatomy, you can start expanding your art to make more diverse bodies.

CHILD'S BODY

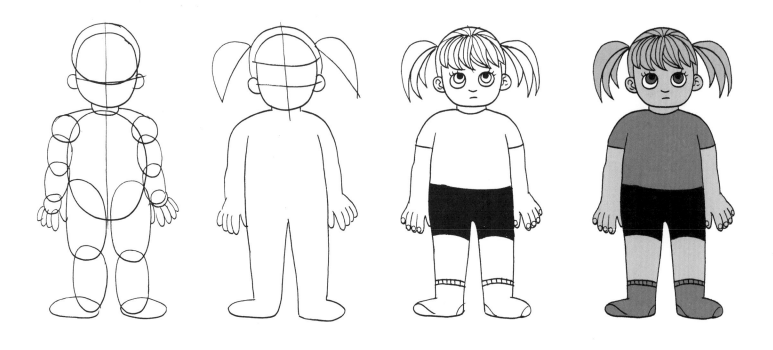

1 2 3 4

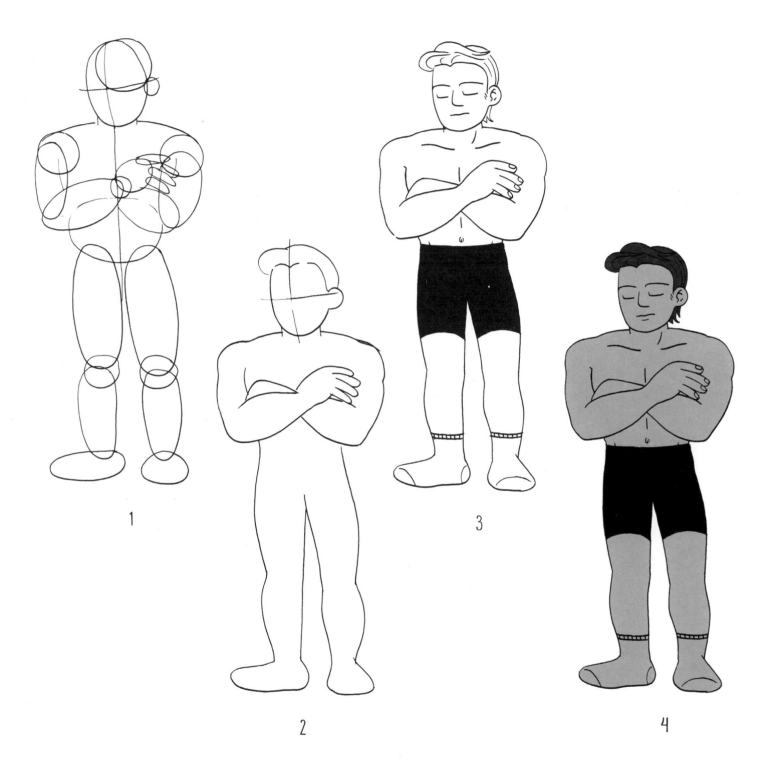

1

2

3

4

WOMAN'S BODY

1

2

3

4

Clothing & Accessories

Have you decided on a style of dress for your character? While it's difficult to make clothing entirely from circles and ovals, these shapes come in handy with certain garments and accessories.

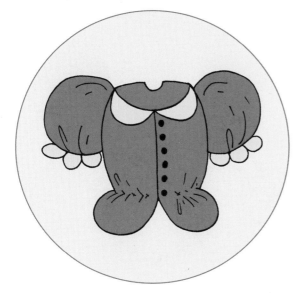

BLOUSES

Blouses with puffed sleeves, round collars, and circular buttons are a great example of circle-based clothing.

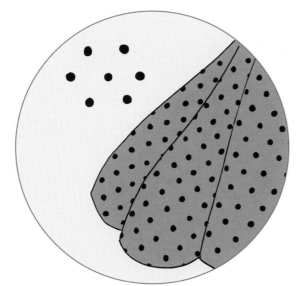

PRINTS

Even if fashion isn't your forte, prints can easily embellish a simple outfit to make it more visually appealing. In fact, you can create one of the most classic prints using just circles. To make a polka-dot print, you simply arrange as many circles as necessary in a repeating diamond shape. Always consider the angle of the drapery when you apply this print to clothing to ensure that it doesn't appear flat.

HATS

From baseball caps to sunhats, head coverings are an easy way to distinguish your figure within a larger cast of characters.

BOWS

Bows might seem like a small detail, but you'd be surprised at how often they can come in handy. Shoelaces, aprons, and hair ribbons are just a couple of things that need to be tied with a bow. Once you're comfortable drawing a bow, you'll love incorporating it into as many outfits as possible.

JEWELRY

Every fashionista needs some baubles to go along with their clothes. Circles and ovals can help you draw pearl necklaces, hoop earrings, rings, and much more.

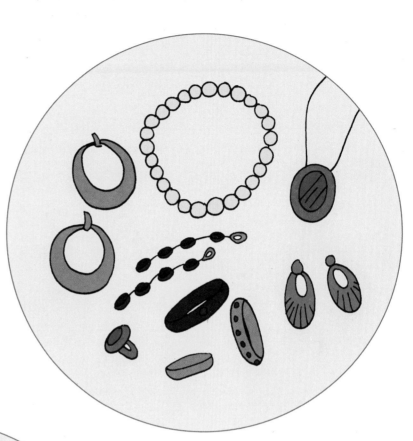

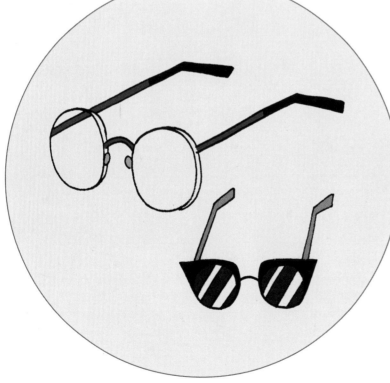

GLASSES

Eyeglasses and sunglasses do more than adorn a person's face. They also inform the viewer of a character's traits or what they may be doing. Are they reading? Are they near-sighted? Are they outside in the sun? These are all things to consider when dressing your character.

Round Characters

To truly understand what circles and ovals are capable of, you need to use them as much as you can. You'll be surprised at the many different kinds of people you can make with these simple shapes.

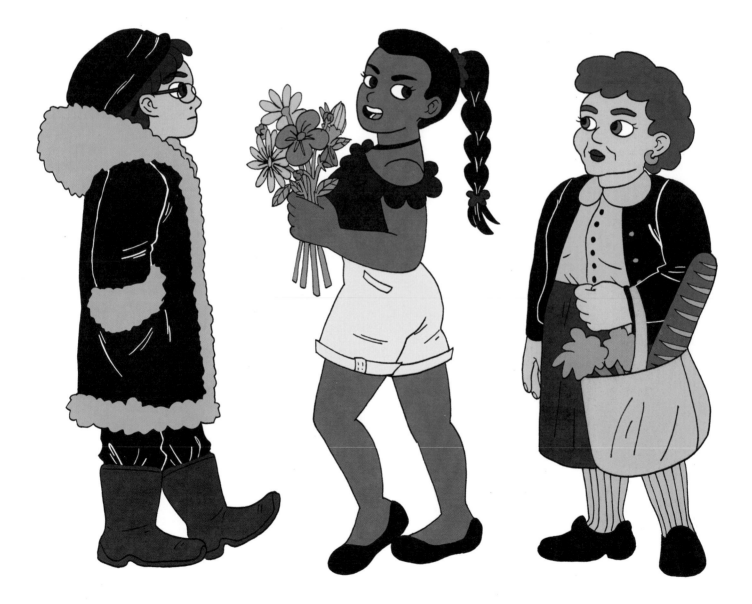

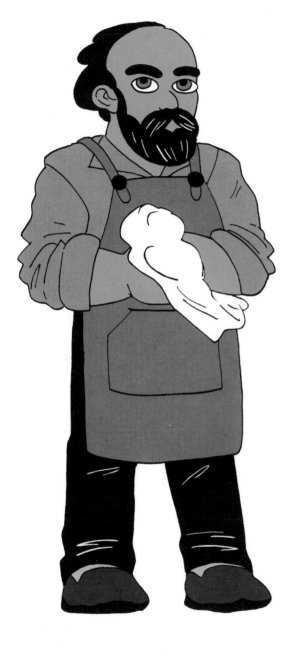

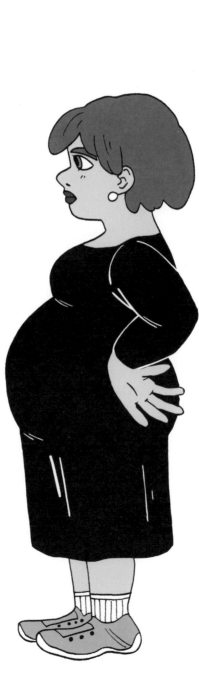

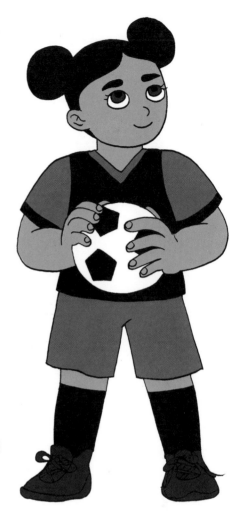

Here are just a couple of examples of unique "round" characters. Use them as a starting point for your own creations!

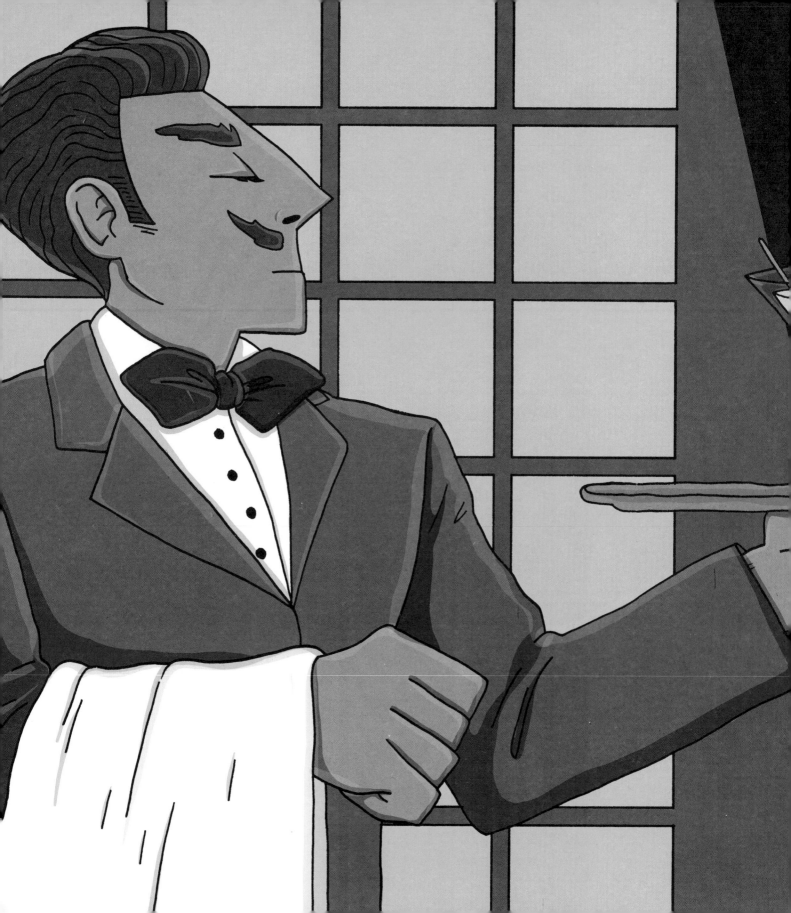

CHAPTER THREE:
What Can You Do with Triangles?

A triangle might not be the first shape that comes to mind when you want to draw a person—but don't let that deter you from using it! This three-pointed shape can be the ultimate sidekick in your drawings and is useful for adding interesting angles when needed. From a long, pointy nose to a pair of stylish boots, there's a lot that triangles can do.

Triangles are key to creating angular faces, which are a great trait for sharp-looking characters, like antagonists.

NOSES

If you've drawn cartoons before, chances are you're familiar with triangular noses. This is a staple of the classic cartoon style, and it's easy to see why. With just a couple of angled lines, you can quickly caricature most nose shapes out there.

To make your own, you simply add a triangle—of any size—to the center of a subject's face. You can either leave the shape as is to keep the playful aesthetic, or erase one line to create an open V-shape.

To avoid this technique from becoming repetitive, however, try mixing up the sizes and placement of the triangles. This will assist you in making more kinds of noses, from long to small.

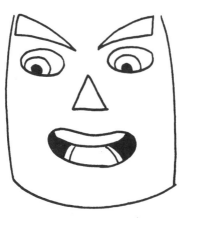
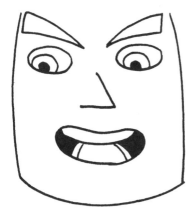

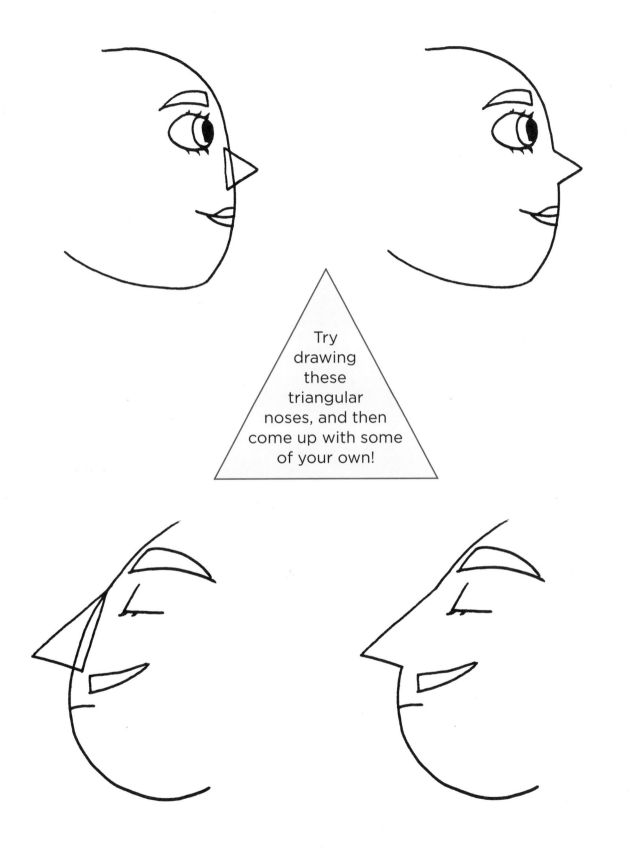

Try drawing these triangular noses, and then come up with some of your own!

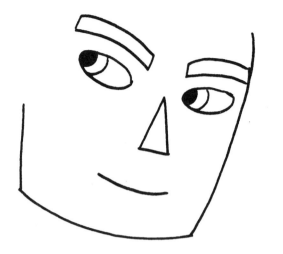

EYES

Although you may not think it at first glance, triangles can help you make distinct eyes that add a lot of personality to your characters. All it takes is the correct placement.

Profile Eyes

When drawing a figure in profile, for instance, the eye will look very different from how it appears facing forward. Triangles are ideal for rendering this angle. All you need to do is place a triangle near the bridge of the nose and make sure the narrow end of the triangle is pointed inward toward the ear. Then you simply add the iris and pupil inside the triangle.

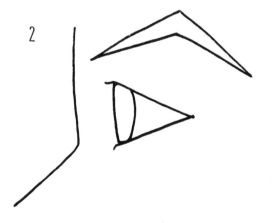

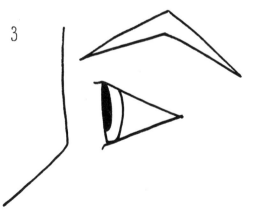

Wide Eyes

Triangular eyes naturally look a little more mischievous compared to other shapes. To draw a pair of wide, sly-looking eyes, sketch two triangles on your character's face, ensuring that the narrow ends of the triangles face inward at the nose. Next, add the iris and pupil inside the eyes.

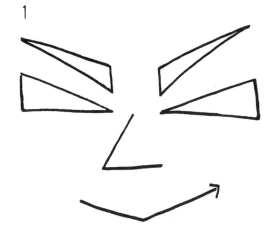

1

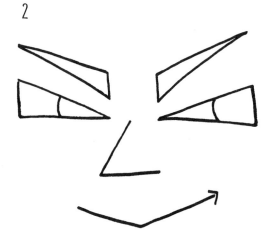

2

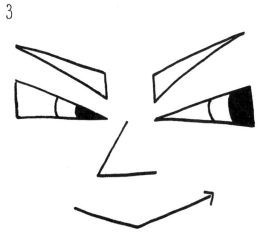

3

Narrow Eyes

Whether you want to draw someone peering at an object far away or would like to capture an expression of suspicion, triangles can help you do that. Simply sketch two very narrow triangles on your character's face and make sure that the wide ends of both triangles face each other. Afterward, add the iris and pupil inside the shapes.

1

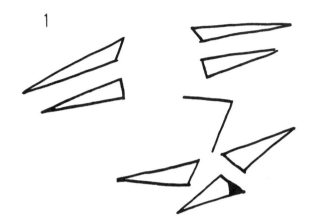

2

3

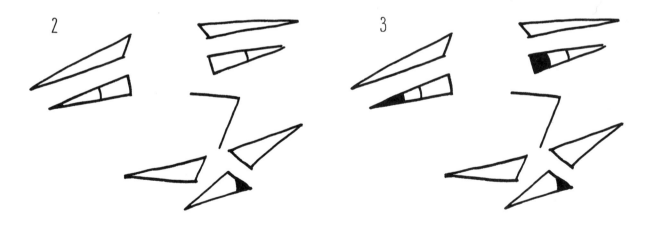

Closed Eyes

We don't always have our eyes open in real life, so it's important to practice drawing closed eyes too. You can easily create a pair of closed eyes by sketching two similarly shaped triangles. Simply draw the shapes at the center of your character's face, and make sure the wide end of the triangle is facing down, toward the mouth.

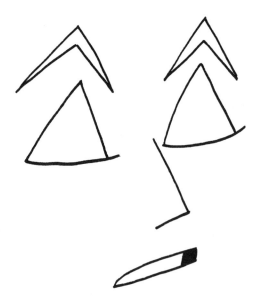

EYEBROWS

Triangles are fantastic shapes for eyebrows. In real life, eyebrows tend to get narrower at one end, and triangles can help emulate that.

Try sketching eyebrows with the wide end closer to the bridge of the nose and see how you like it. Then flip the triangle so that the pointy end is at the nose and the wide end flares out toward the hairline. With just one shape placed at a different angle, you've made two very striking pairs of eyebrows.

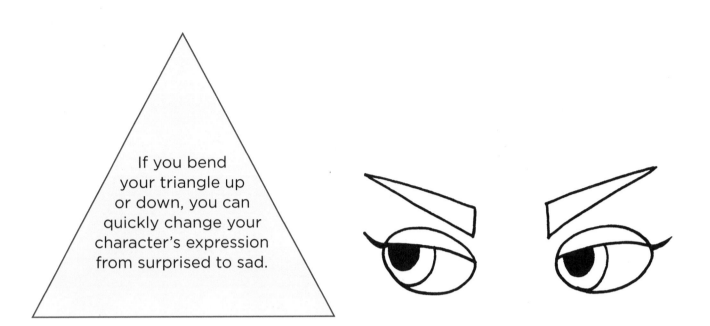

If you bend your triangle up or down, you can quickly change your character's expression from surprised to sad.

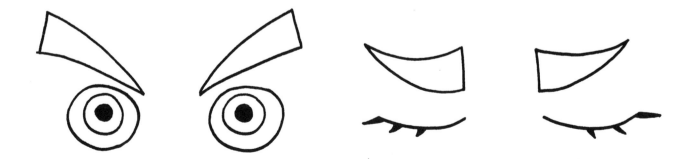

FACIAL HAIR

Making your characters distinguishable from one another is vital in cartoons, and facial hair can help with that. A pair of well-placed triangles can easily transform into a striking mustache, a well-groomed goatee, or even a clipped beard. Exaggerate the sizes to make even more flamboyant styles.

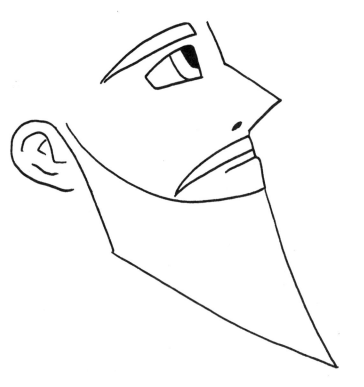

CHINS

A triangular head isn't something you see every day, but a pointy chin might be. Adding a triangle to a basic oval head will instantly change the appearance from soft to contoured. And while this is especially helpful for antagonists, it's also more versatile than that. A pointy chin can look good on many types of characters, especially at different angles.

Try adding a triangle to a head from the front, in profile, and from the side, and compare the results. You'll find that this simple addition will age your characters—and perhaps even give them more of an edge.

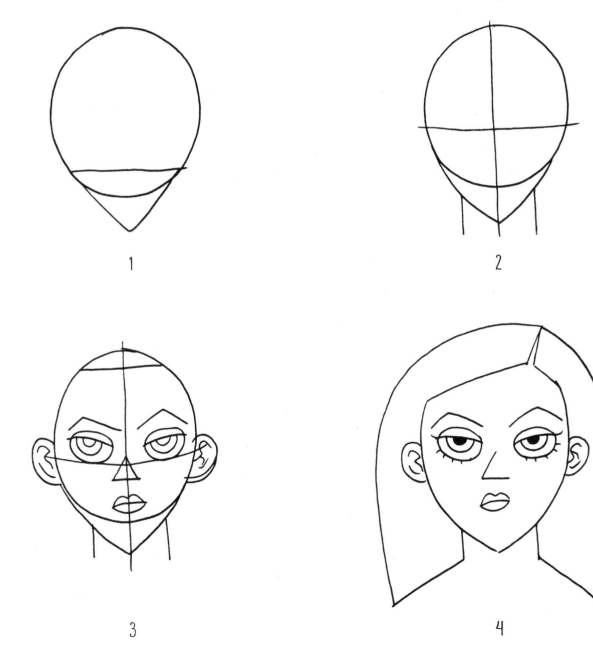

1

2

3

4

1

2

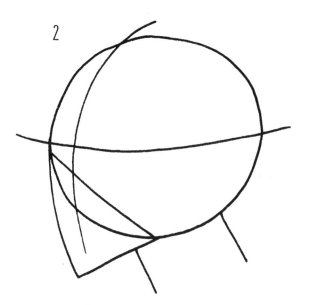

3

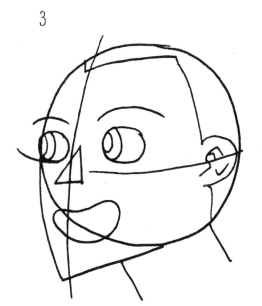

4

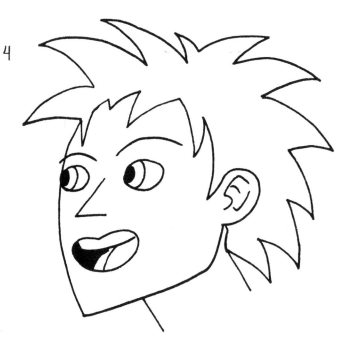

1

2

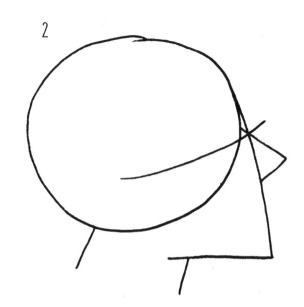

3

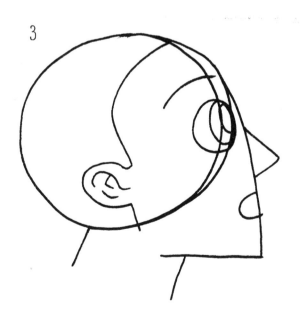

4

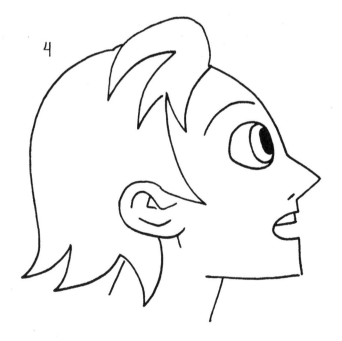

Hands

Hands say a lot about your character, so drawing sharp, narrow fingers will give the impression of a severe personality. Female villains, for instance, will often have talon-like fingers with long, pointed nails.

Fortunately, this type of stylized hand is fairly easy to create. All you need to do is add long triangles to a circular or square palm at the correct length and distance. Then add a small line at the tip to demarcate the nail. Practice this approach from a couple of different angles to see how you like it.

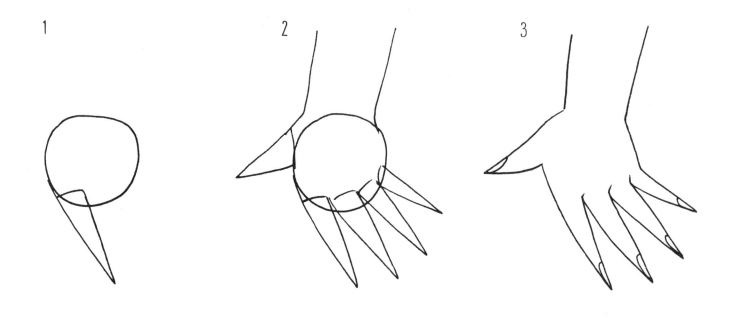

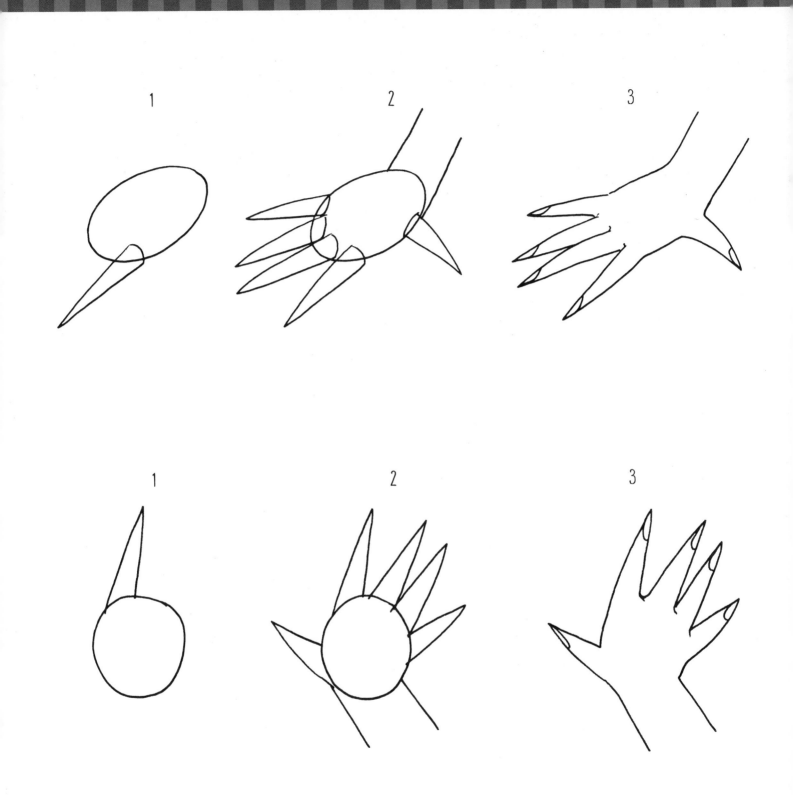

Shoes

Shoes might be the last thing you think of drawing (literally), but that doesn't mean they're any less important. In fact, shoes can quickly inform the viewer of your character's style of dress or their occupation, so it's important to practice sketching them. Although shoes, like all clothes, come in a variety of styles, triangles will help you nail the basics of most of them—so definitely pay attention to them!

FROM THE FRONT

When drawing shoes from the front, you'll want to keep in mind that the object will appear "squashed" due to foreshortening.

1

Begin by sketching an isosceles or equilateral triangle.

2

Add two vertical lines on either side of the top of the triangle.

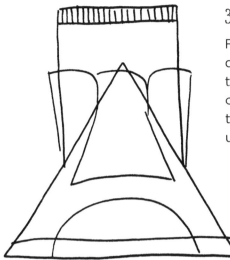

3

Fill in the triangle with details, like the sole of the shoe and the basic outline of the shoe's tongue (the front flap underneath the laces).

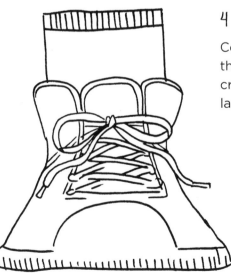

4

Continue fleshing out the shoe until you've created a detailed lace-up sneaker.

PROFILE

The profile angle tends to be uncomplicated and straightforward, allowing you to focus on the basic elements of the shoe.

Here, you will want to use a right triangle as the foundation. Then again create an ankle using two straight, vertical lines. Fill in the shoe with details you would find in a basic lace-up sneaker, like the lip and the rubber sole. Finally, sketch the laces and finish them with a bow.

1

2

3

4

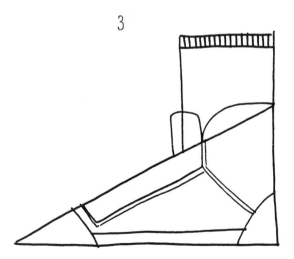

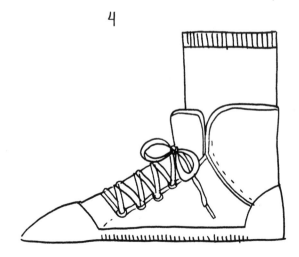

BACK

Although drawing things from the back is not as fun to practice, it's still an essential pose to exercise.

You will begin by drawing an isosceles triangle like the one you use to draw a shoe from the front (page 60). Add two straight vertical lines as usual to make the ankle. Draw the contour of the shoe's collar as it wraps around the ankle, and sketch the sole at the bottom. Refine the details.

1

2

3

4

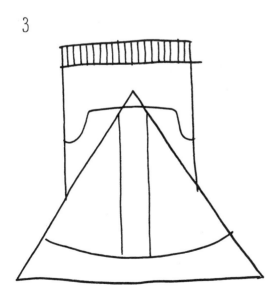

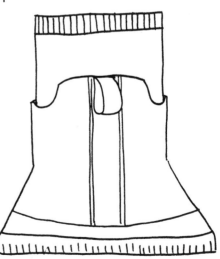

OTHER TYPES OF SHOES

There are many other types of shoes aside from sneakers, so you can employ these same techniques on other styles of footwear as well.

Boots, for instance, are a fun, versatile shoe that often uses a triangular shape. You can even make simple black flats by drawing two triangles within a larger triangle. And there are many other types of shoes you can design too!

1

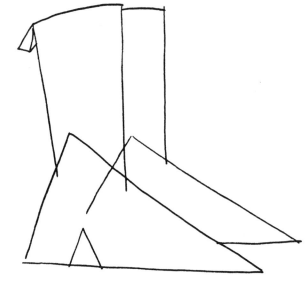

2

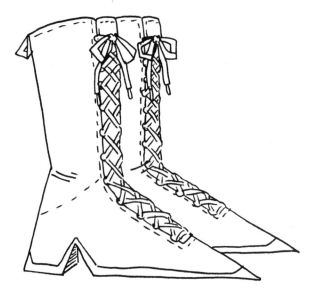

3

1

2

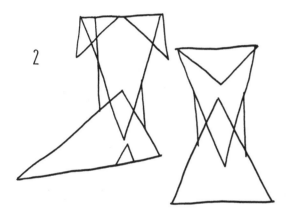

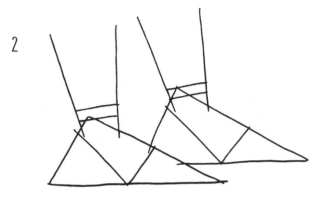

3

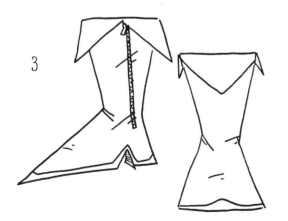

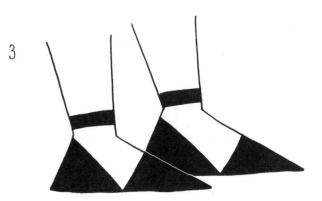

Clothing & Accessories

When it's time to dress your character, triangles can definitely help you out. This is another instance in which the shape's greatness can be seen in its adaptability.

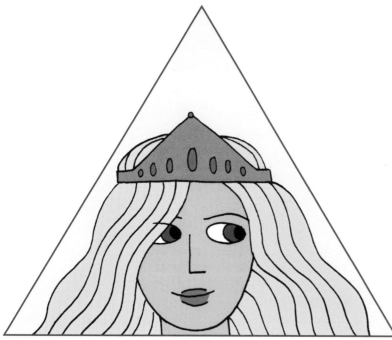

CROWNS & TIARAS

Want to make your character look like royalty? There's no easier or better way to do that than by adorning them with a crown. By manipulating triangles, you can easily make regal headwear, including tiaras and diadems.

JEWELRY

Pointy jewelry is the perfect accessory for a pointy character. Create chic earrings by sketching a smaller triangle inside of a larger triangle, and design enviable gems by combining two triangles to make a diamond shape.

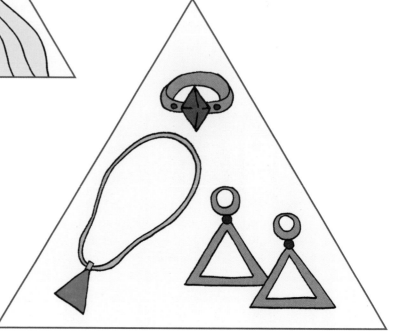

BOW TIES & RIBBONS

Accessories are the key to a good outfit in real life and in cartoons. You can easily spruce up your characters by designing chic bow ties. They simply require a combination of triangles. Likewise, triangles can make quick and easy bows for shoes, hair, shirts, and more.

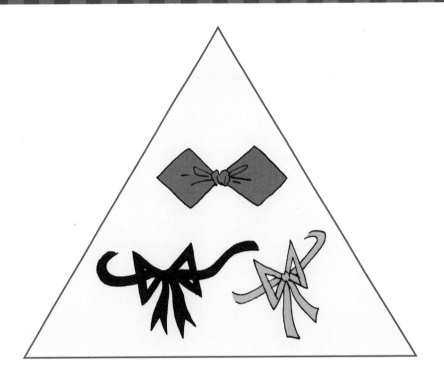

JACKETS & SHIRT COLLARS

Understanding the basic design elements of clothes will help you create your own "closet" of go-to outfits for characters. Triangles appear in many different kinds of apparel, from suit jackets to shirts. In particular, triangles can be seen in the collars of these garments. See for yourself!

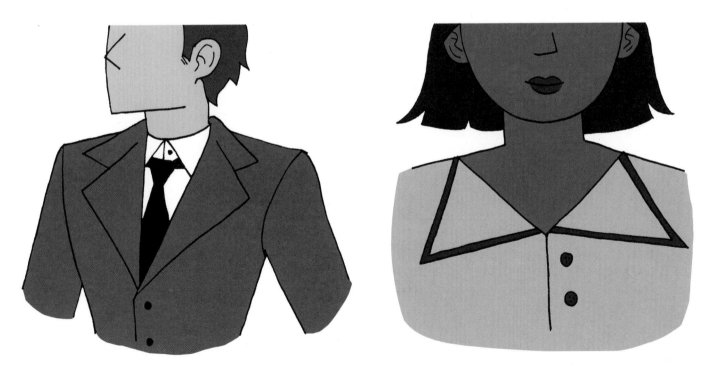

Bodies

Triangles have such a distinct shape and sharpness that, when utilized, they will greatly affect the appearance of your characters. You'll find that many villains, villainesses, aristocrats, standoffish types, and generally more mischievous characters tend to possess triangular bodies and features.

Look at the examples here. Practice using triangles to create the bodies of a woman, man, and child, and see the different effects the triangles have. While you can't use a triangle for every body part, they are commonly utilized for the shape of the torso and hips to make a very defined waist. After you've gotten comfortable using triangles in basic anatomy, you can get more creative and make your own versions of these bodies.

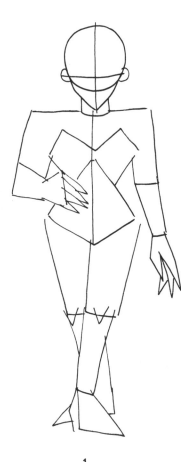

1

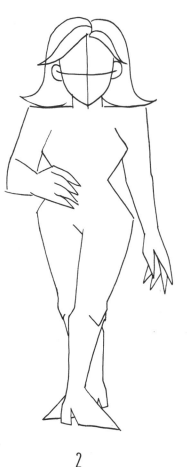

2

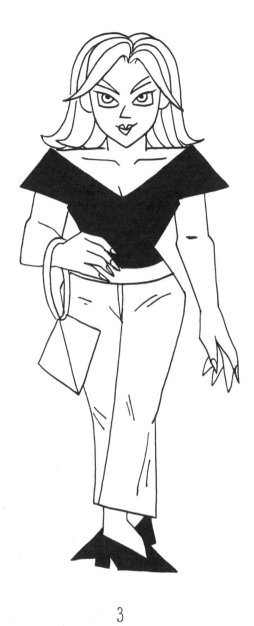

3

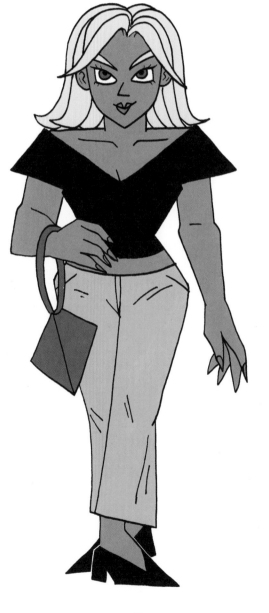

4

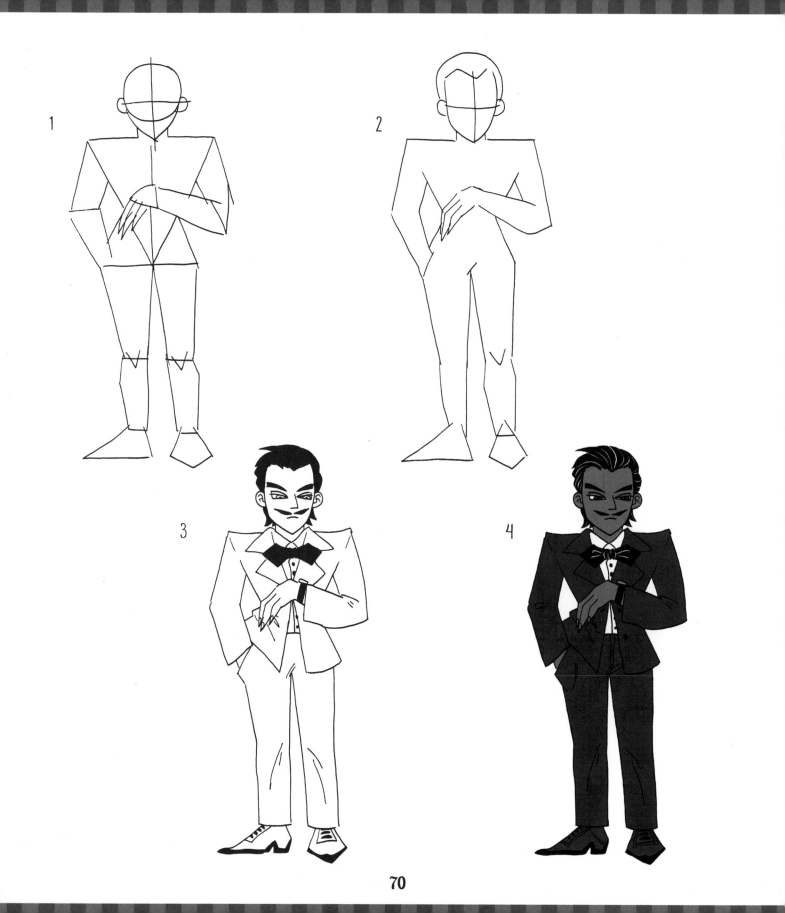

1

2

3

4

Triangular Characters

We've explored some ways in which triangles can be incorporated into cartoon faces and figures, but it is by no means a final list. To truly hone your skills, it is important to practice using them on their own, finding new and creative ways to employ them in your art.

If you need some help getting started, this collection of triangular characters can be a starting point.

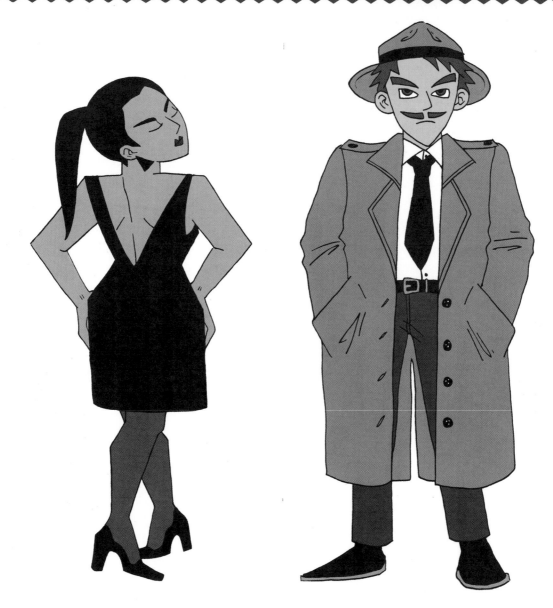

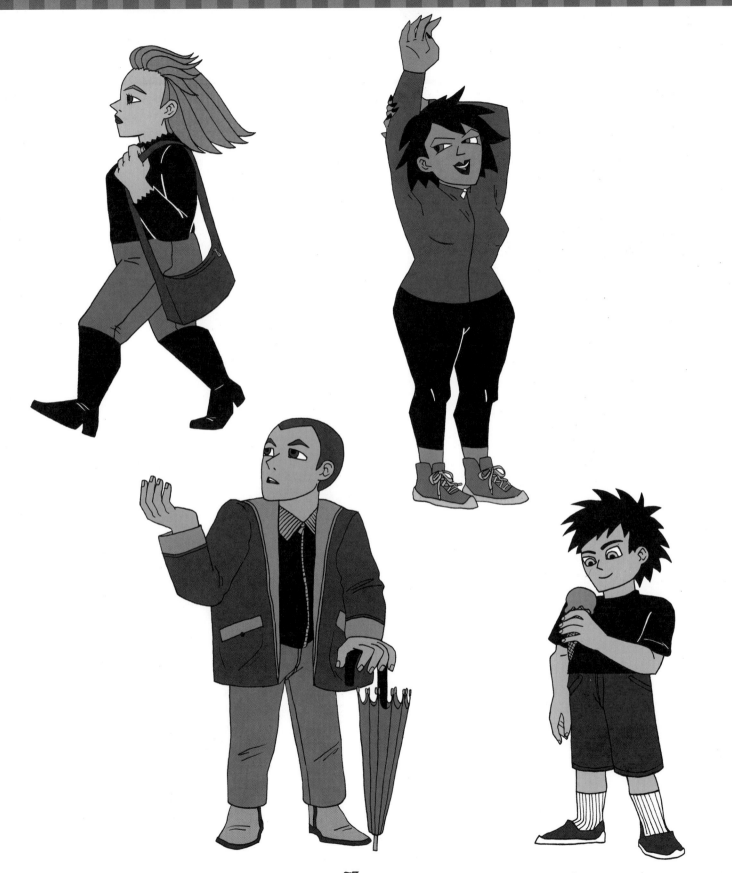

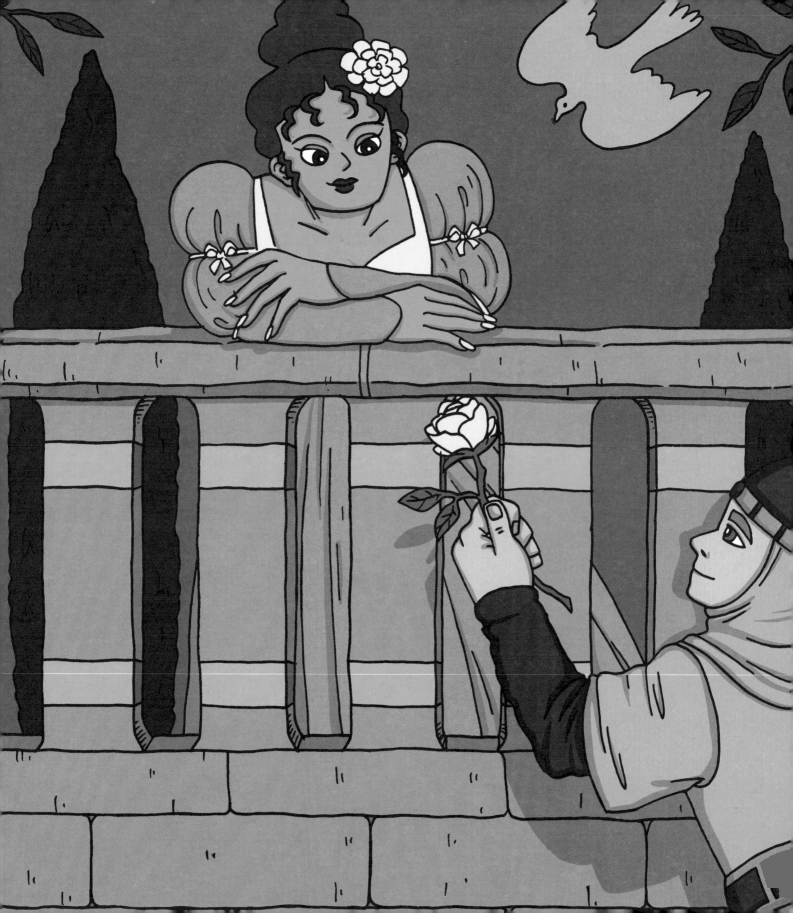

CHAPTER FOUR:

What Can You Do with Squares?

If each shape has its own personality, then the square is definitely the most serious of the group. With its four sides and four points, it has an instantaneous blocklike effect. However, just because the square a little clunkier to draw, that doesn't mean it's any less useful. Depending on what you want to draw, you may find that squares and rectangles are your most useful tool.

Faces

EYES

While you won't find rectangular or square eyes in real life, in cartoons, they're more prominent than you might think. They can make the "windows to the soul" look much more extreme and stylistic.

Tall Rectangular Eyes

Rectangular eyes that are lengthened vertically will appear immediately zany and—because of the different angles—a little bit futuristic.

While you can choose to fill the eye with a rectangular iris and pupil, that will give your character a digital or robotic look. That is why, in this example, I have chosen to fill the rectangular eye shape with a circular iris and pupil.

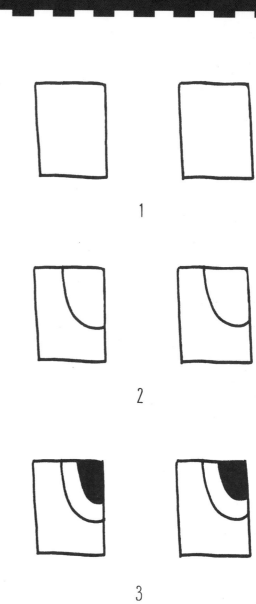

76

Wide Rectangular Eyes

If you choose to stretch rectangular eyes horizontally, you will see that they look marginally more realistic. Wide rectangular eyes are a little more practical for most characters and can adapt to additional personality types.

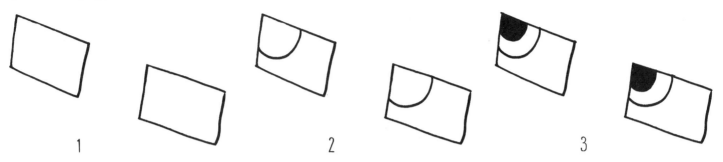

Square Eyes

Rectangular eyes appear playful due to their on-the-nose exaggeration. Squares, on the other hand, are a little less silly and more bookish in appearance. They can make a great trait for characters that are a little on the brainier side.

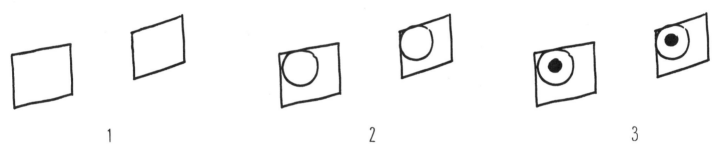

Bendy Eyes

After seeing the eyes you can make using straightforward rectangles and squares, try manipulating them to make the eyes look more peculiar. By bending a rectangle in the middle, for instance, you can make a pair of eyes that looks like the person may be smiling.

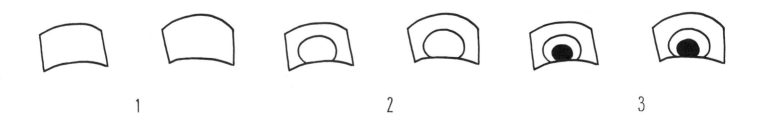

NOSES

While you may not use squares and rectangles to draw most noses, the fact that you can is useful and should be explored. Start by sketching a rectangle where you want to place the nose—this is typically about halfway down the face. Then erase two sides of the shape until you've created an L. This is a good technique for making larger noses with a prominent bridge.

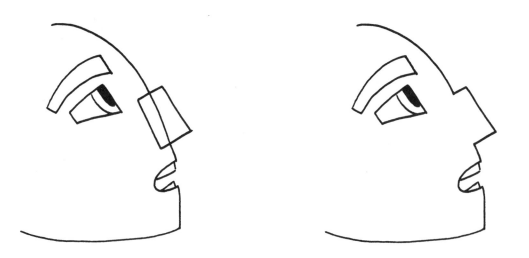

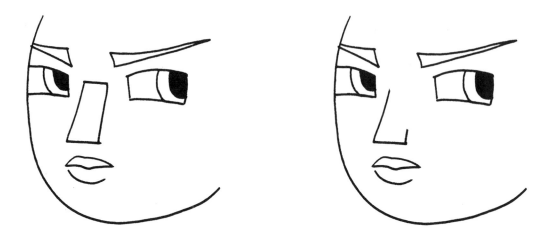

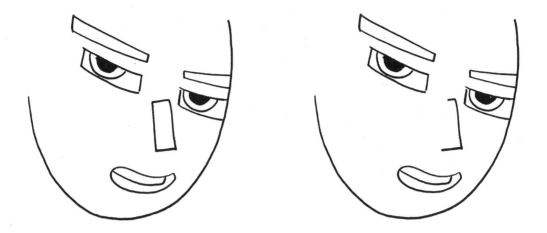

EYEBROWS

Distinct eyebrows are a terrific way to frame your character's face, and the way you choose to draw them will have a large effect on someone's appearance. Thin eyebrows appear delicate and refined, for example, whereas thicker eyebrows can come across as more youthful and, in some cases, boisterous.

However, the most important function of eyebrows is their ability to communicate emotion. Try using rectangles to create a variety of different eyebrow shapes and see how they affect the eyes underneath.

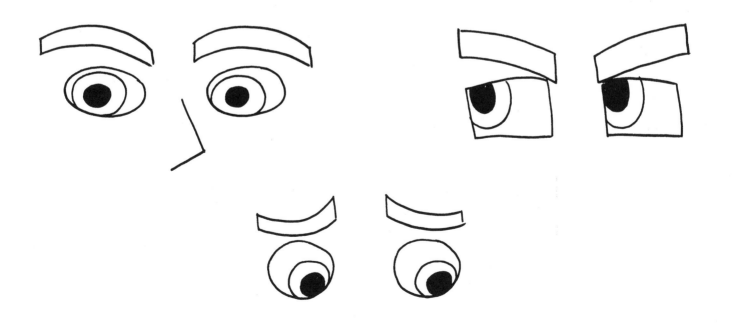

Heads

Have you ever heard of someone being described as having a "strong jaw" or a "wide forehead?" Well, these characteristics often derive from square and rectangular shapes. In fact, you can exclusively use these four-sided forms to create distinct heads for your characters.

FRONT HEAD

A head facing forward is an essential pose to practice. The key to doing it well is to make it as symmetrical as possible. Fortunately, because squares and rectangles have more sides and angles, it's easier to measure proportions and find the right place to put the facial features.

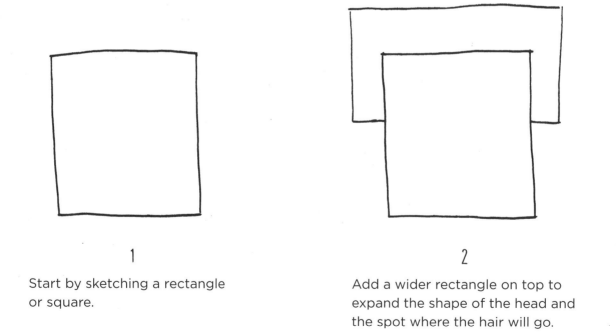

1

Start by sketching a rectangle or square.

2

Add a wider rectangle on top to expand the shape of the head and the spot where the hair will go.

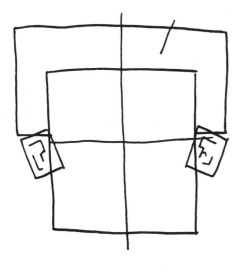

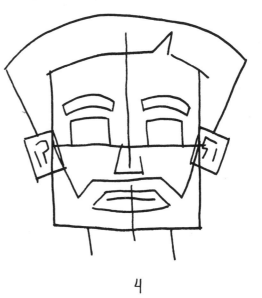

3

Add a pair of rectangular ears on either side of the head.

4

Divide the face in half with a vertical and horizontal line, and use those markers to place the eyes, nose, and mouth on the head.

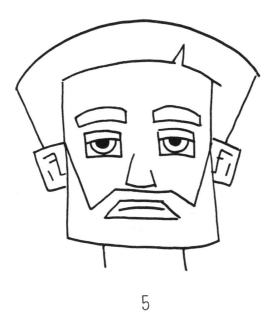

5

Cap it off with details like facial hair.

HEADS TO THE SIDE

When drawing heads from the side, the angles of squares and rectangles will be your best friend, adding appealing corners and facets to your characters' faces that will catch the viewer's attention. Plus, heads rendered from the side have the benefit of not needing to be perfectly symmetrical.

So, whether you're drawing a head from the right or left, you'll always want to begin with a rectangle. Then expand the size of the head by adding another rectangle to the back of the first. Find the center of the rectangle and add the ears; then draw horizontal and vertical lines on the head and place the eyes, nose, and mouth. All that's left is to flesh it out with any remaining details.

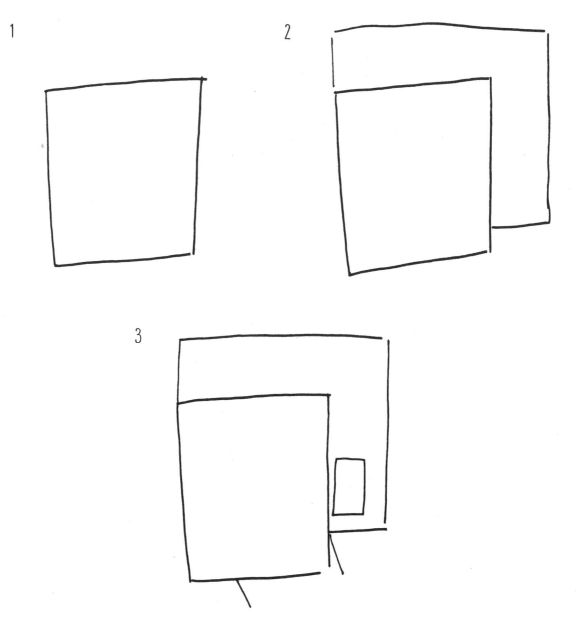

4

5

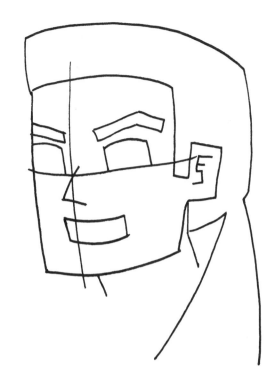

6

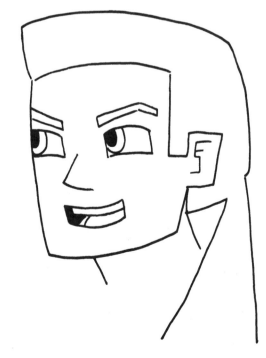

1

2

3

4

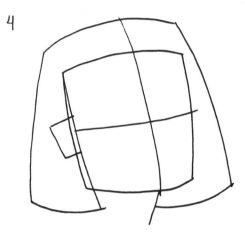

5

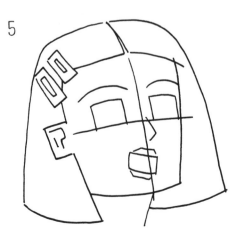

6

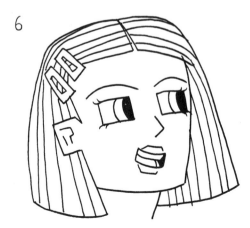

LOOKING DOWN

By now, you've probably realized that there's a lot to keep in mind when drawing a character's head. It can be tempting not to try more unusual perspectives in your drawings—but if you practice sketching different angles, you'll find that they're not as challenging as you think.

1

Once again, begin with a rectangle.

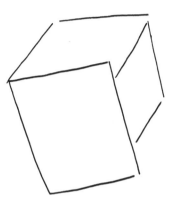

2

Next, add two squares to the back of the rectangle to create an almost cubelike shape.

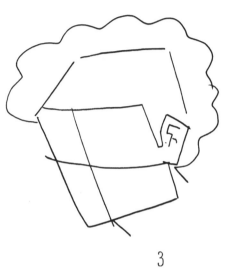

3

Add ears and hair to the cube, as well as a vertical and horizontal line to the face.

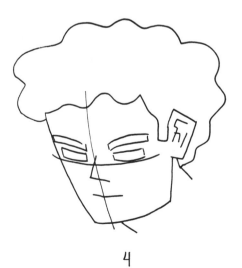

4

Place the facial features along the guidelines and fill in the details.

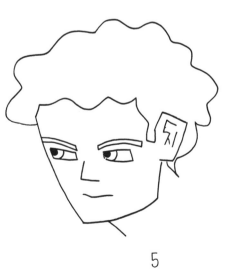

5

Erase the guidelines to finish your portrait.

85

Hands

Even if you don't "talk with your hands" in real life, cartoons depend on the visual appeal of hands. Want to make hands that stand out? Squares and rectangles can help with that. Since these shapes have such a solid appearance on their own, you will find that by using a square for a palm and rectangles for fingers, your hands will come across as strong and bold.

OPEN PALM

Practice using these shapes by drawing a flat, open hand. Start by sketching a square to create the palm. From there, you can use rectangles of various sizes to add all the fingers to the palm. When in doubt about the proportions, always use your own hand as a reference.

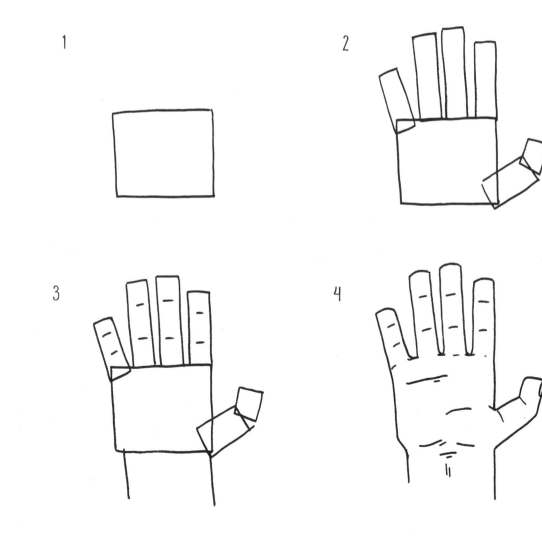

HANDSHAKE

After sketching the palm-side of the hand, we'll turn it over so that the back of the hand is facing the viewer and the fingers are close together. This pose can be used if your character is about to shake hands with someone. Use the same techniques to ensure that all the fingers are appropriately sized relative to the palm.

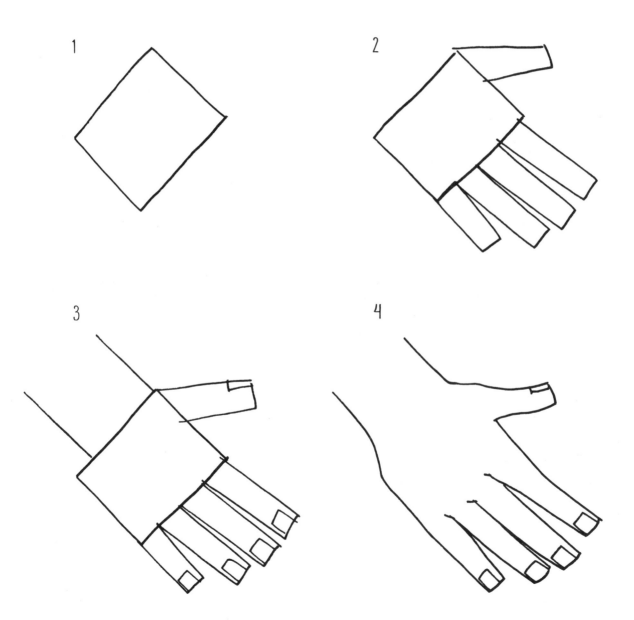

LIFTING HAND

Drawing a hand that is slightly lifted is a great catchall gesture that can easily communicate different things like "not sure," "maybe," or "here it is." Start with a sketch of a square palm and add the fingers in a layered way. The pinky should be lifted slightly higher than the others, and the thumb should extend in the other direction.

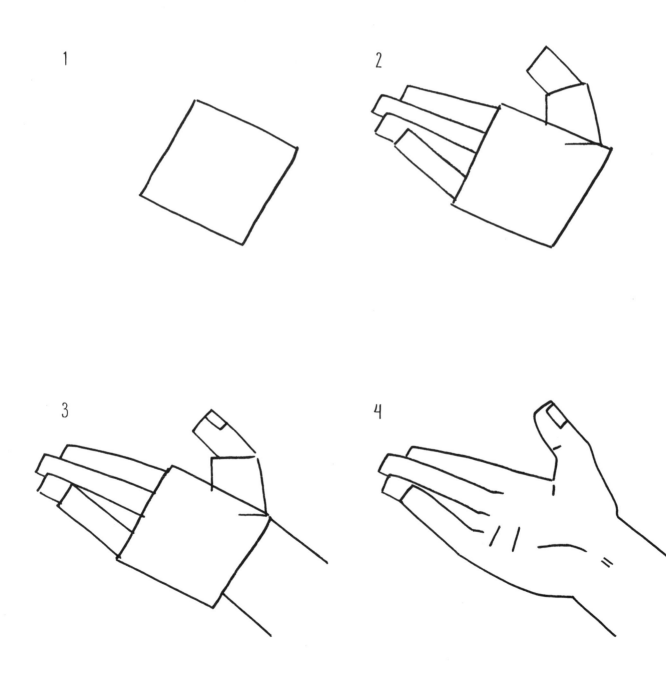

1

2

3

4

HAND IN PROFILE

While practicing drawing heads in profile is commonplace, sketching hands in this angle is not often done. Nevertheless, this pose can come in handy, especially if your character is trying to stop someone or something. To recreate it, start with the square palm, and add the fingers from the index finger to the pinky. Sketching the thumb can be tricky, as it should appear much closer to the viewer but bend slightly backward.

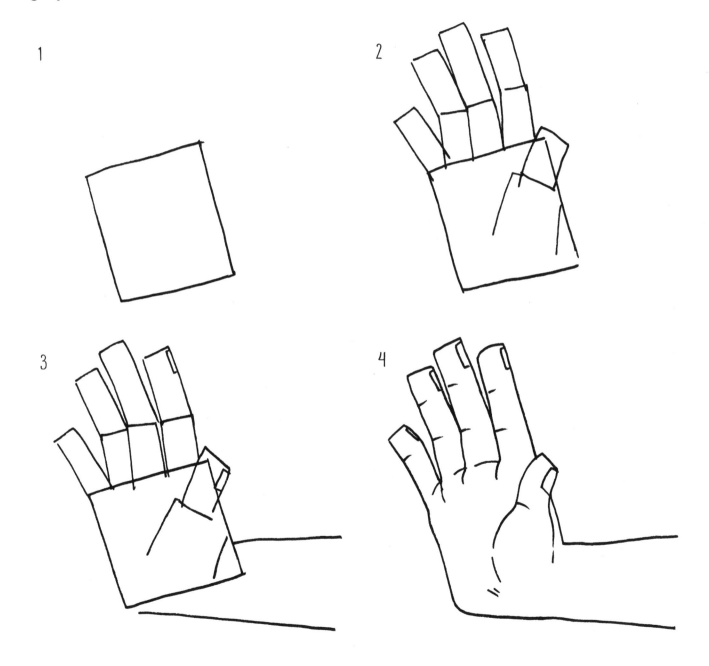

FIST

After practicing how to draw fingers extended, it is equally important to sketch them when they are curled into the palm. While a fist may look complicated, squares and rectangles make this hand gesture much more approachable.

Using the square palm as the foundation, add shorter and thicker rectangles to one side until it looks like the fingers are folded into the middle of the palm. Add the thumb afterward so that it rests on the outside of the fist.

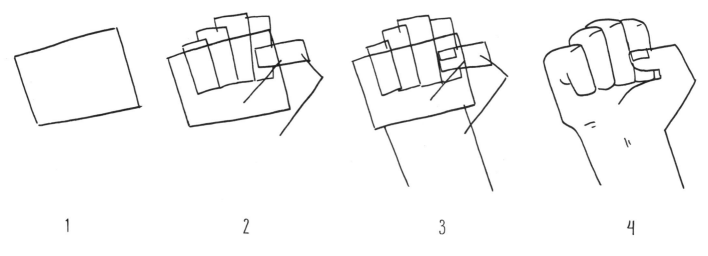

1 2 3 4

POINTING FINGER

Once you know how to draw a fist, you can use a very similar approach to create a pointing hand. All you need to do is create the fist (see above), save for the first—or index —finger. This should be extended to its normal length in whatever direction the hand is pointing.

 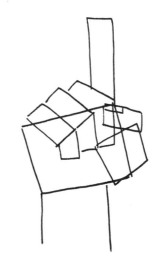 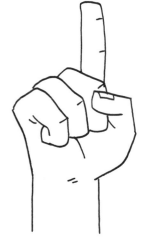

1 2 3 4

Bodies

By now, we've established that squares are chunky shapes to use. If you want to create a cartoon body using exclusively squares and rectangles, you will find that it produces a similarly blocklike effect. While this might sound like it would pigeonhole your character into one personality or trope, it's actually quite malleable. Strong, husky characters are certainly one type that would benefit from square bodies, and conversely, scholarly characters are another category that can be made with these shapes.

Test the effects of squares and rectangles by using them to make the bodies of a woman, man, and child. You can easily render the torso, head, and limbs using various sizes of rectangles. If you feel comfortable with anatomy and measuring proportions, you can try your hand at making a range of body types with these shapes.

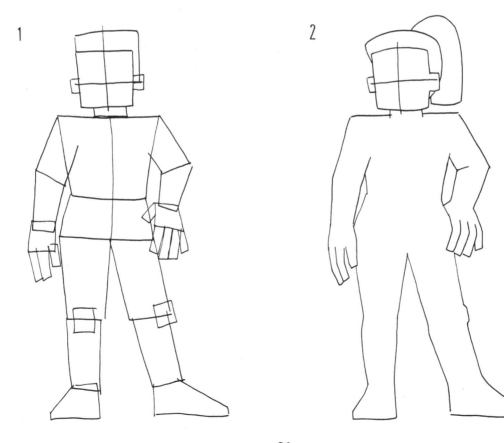

1

2

91

3

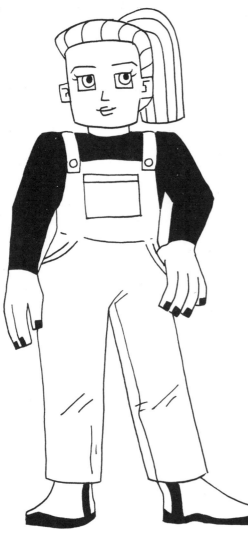

4

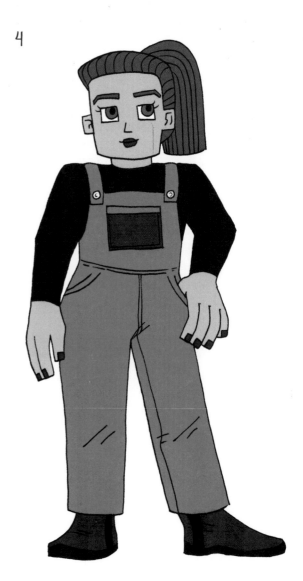

1

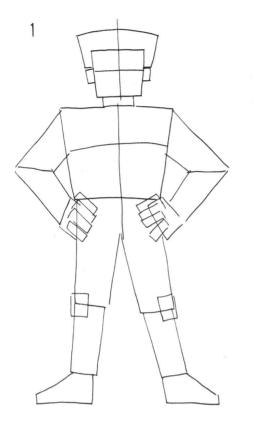

2

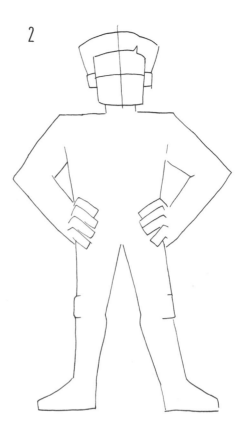

3

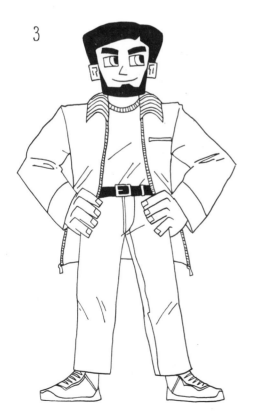

4

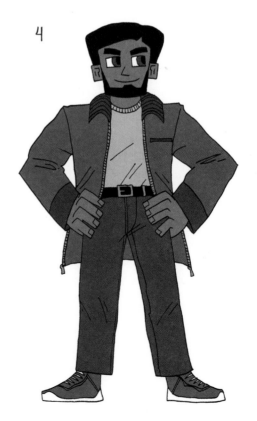

1

2

3

4

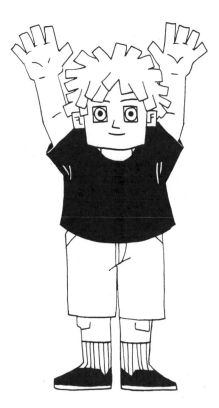

94

Clothing & Accessories

If you want to draw eye-catching, standout characters, then having a basic understanding of clothing and accessories is a must. Squares and rectangles can help you sketch a variety of attractive pieces that you can add to mix and match in your art.

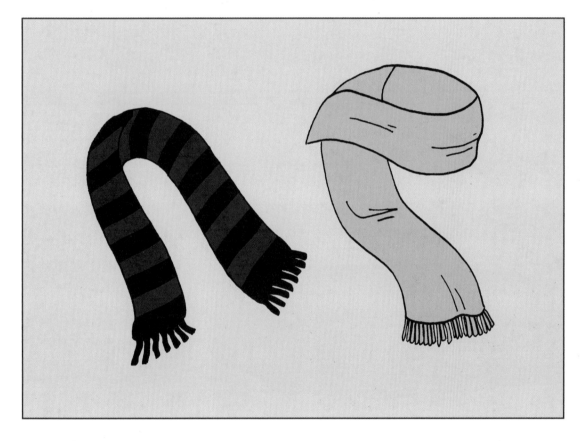

SCARVES

Not only are scarves the quintessential cold weather accessory, but they're also a fantastic object to use when you want to add an element of motion to your artwork. Wrap a scarf around a character's neck, for instance, and let one of the ends drift in the direction of the wind. Suddenly, the scene will look much more cinematic!

GLASSES

While there are many kinds of lenses available, most of them tend to be square-based. So, take advantage of your newfound mastery of the four-sided shape and try adding some glasses to your characters. Want to make them sunglasses instead? All you need to do is fill the shape of the lenses with shading, black, or color and add some areas of light.

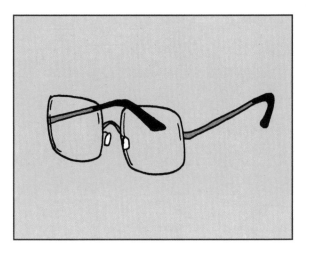

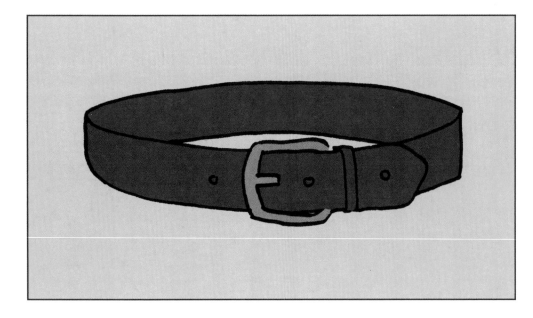

BELTS

A belt can add definition and glamour to an outfit. This also applies in drawings of people. Fortunately, belts are pretty straightforward to draw. All you'll need to do is create a long rectangle that winds around the body of the person and embellish it with a buckle.

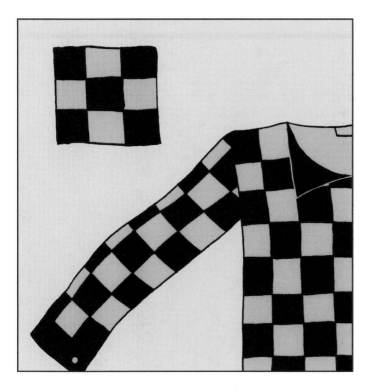

PRINTS

If finding new silhouettes to adorn your figures isn't something you want to spend too much time on, then color and print will be instrumental in your art. The humble square can help you create two distinct prints, just by repeating it in a certain way. A checker print, for instance, simply requires you to draw alternating black-and-white squares (or the colors of your choice). Similarly, you can tilt squares to create a diamond shape, and use that to make an argyle print.

The key to making your prints look good is to manipulate them according to the drapery of the garment so that the pattern never looks like it was "stuck on top."

BAGS & WALLETS

Squares and rectangles can help you draw wallets, handbags, suitcases, briefcases, messenger bags, and more.

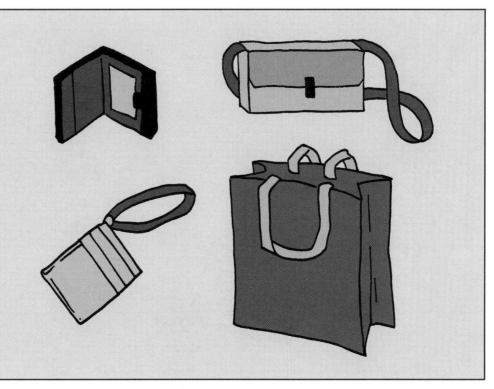

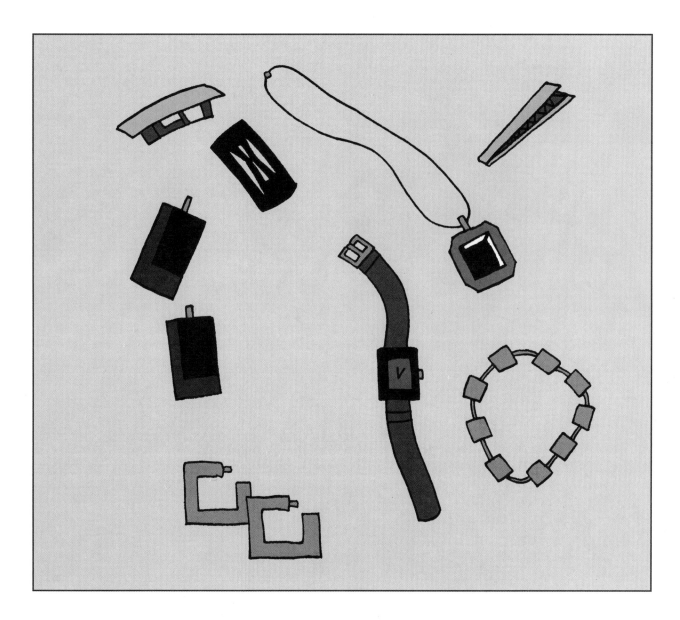

JEWELRY & HAIR ACCESSORIES

The best way to finish your characters outfit is with unique accessories. A square-faced wristwatch, rectangular earrings, and rectangular barrettes are just a few of the eye-catching items you can sketch on your figures to make them stand out in a crowd.

Square Characters

Now that we've gone over the basics of using squares and rectangles to draw cartoon people, it is time for you to practice them on your own. Test your skills and stretch your imagination by sketching as many unique people as you can think using just these shapes.

Take a look at these examples of "square" characters and let them inspire your own figures!

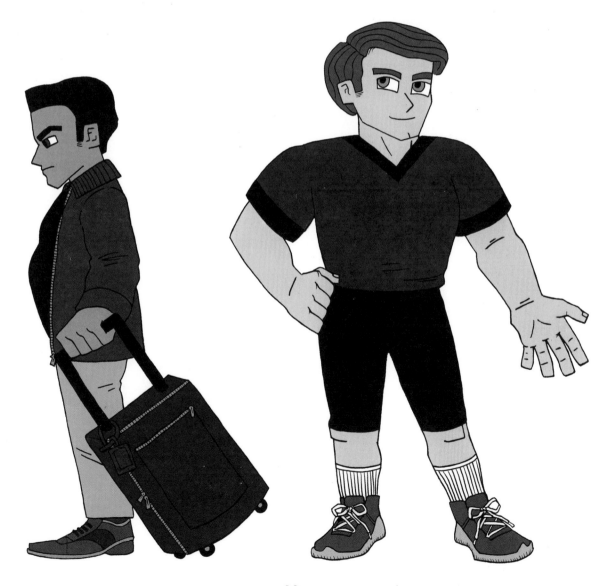

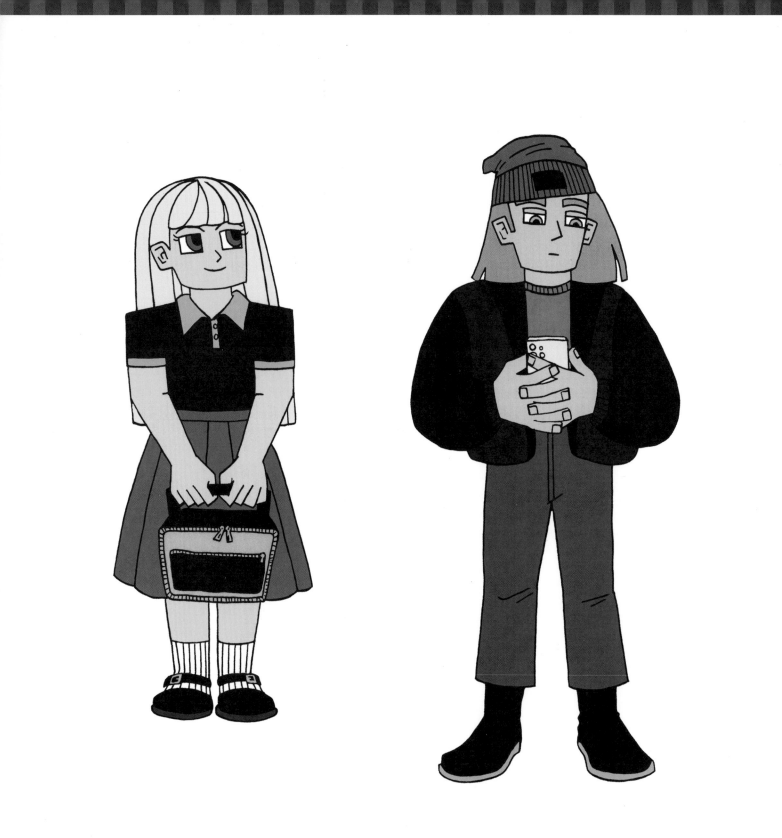

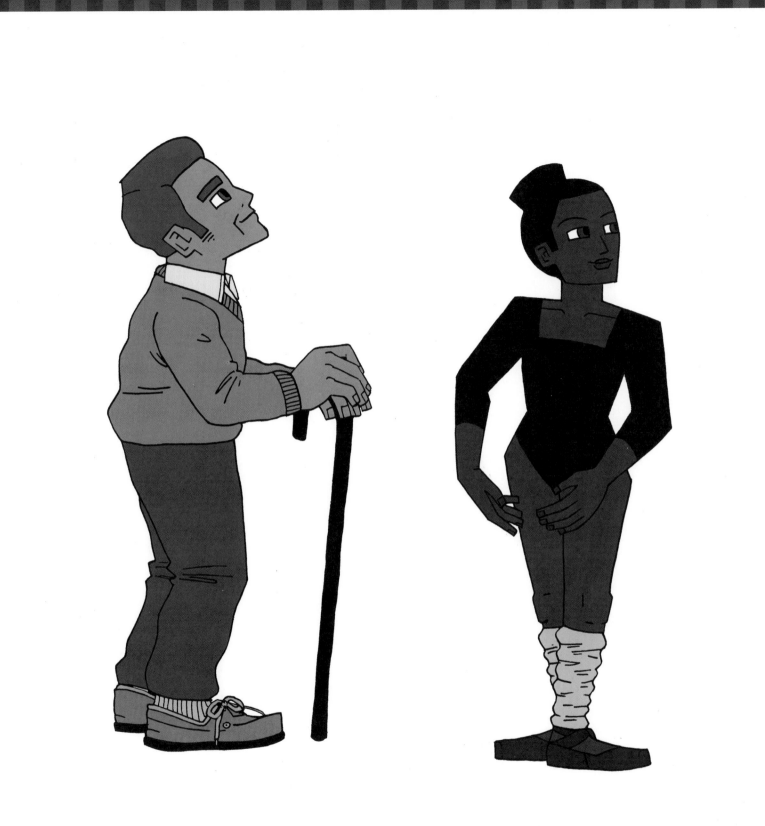

CHAPTER FIVE:
Putting It All Together

By now we've learned that circles can give a character a rounder and more youthful appearance; triangles can make a character appear mischievous or even antagonistic; and squares imply a more serious personality. So what happens when you make a character by combining all of these shapes? Pretty much anything!

While creating a character with just one shape is very effective and fun, it might also feel a little limiting. Using all the shapes will help you render a variety of interesting cartoon people that look a little more relatable which, in turn, will help you build a more diverse world.

How to Make Unique Characters that Stand Out

People enjoy cartoons because they're fun to look at. Between their cute, exaggerated faces and colorful clothing, there's a lot that goes into making them. The key, of course, is to make a character that can grab the attention of the audience and is not easily forgettable.

Want to make your own unique characters using the three shapes we've gone over? Then you'll need to pay attention to three components: head and hair, body, and clothing. While we've gone over these factors in previous chapters, now it's about taking it to the next level.

1. HEAD & HAIR

The head of your character will most likely be the first thing your audience sees. The facial features you choose will determine whether your character appears to be a young, joyful protagonist (round face, big eyes, smile) or a cranky, wizened villain (pointy face, long nose, scowl). But don't forget about the hair! Big hair, short hair, no hair, or head coverings will all help distinguish your character from a larger cast and make them appear unique.

2. BODY

Whether your character is tall, short, slim, muscular, or curvy will inform viewers about your character's age, lifestyle, and background. Not only that, but the body is another factor that can distinguish or not distinguish your character in a crowd. Are they super tall or of average height, for instance? Sometimes a main character is deceptively ordinary, while others are unique.

3. CLOTHING

The type of garment you choose to put on your character will tell the viewer what your character's doing (firefighter's uniform = firefighter, superhero costume = superhero) and even how well they're doing (fancy suit = good, torn clothing = not so good). Often, cartoon characters will only wear one or two types of outfits, so it's important to get this right.

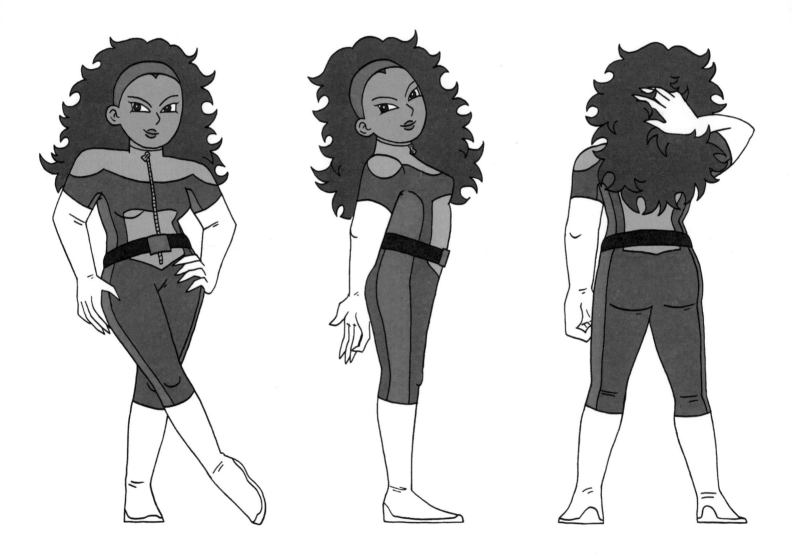

Head & Hair

Once you get the hang of it, heads and hair can be great fun to draw. They offer a way to experiment with character design without committing fully to drawing a body and clothing. And if you found it challenging in the previous chapters to create faces using just one shape, this time you'll incorporate everything you've learned, which means having have a plethora of options at your disposal. The only dilemma will be making a choice from all the options!

Example 1

For this first head, start by drawing an oval, and then overlap it with a large circle. Then add a pair of semicircular ears and a short neck. Next, sketch the hair using soft, bouncy lines; add a pair of triangular earrings to the ears; and construct the shoulders using straight, sharp lines. Make the face by sketching a pair of triangle eyes, rectangular brows, a round nose, and round lips. In the last step, add any necessary details and go over it with color (if desired).

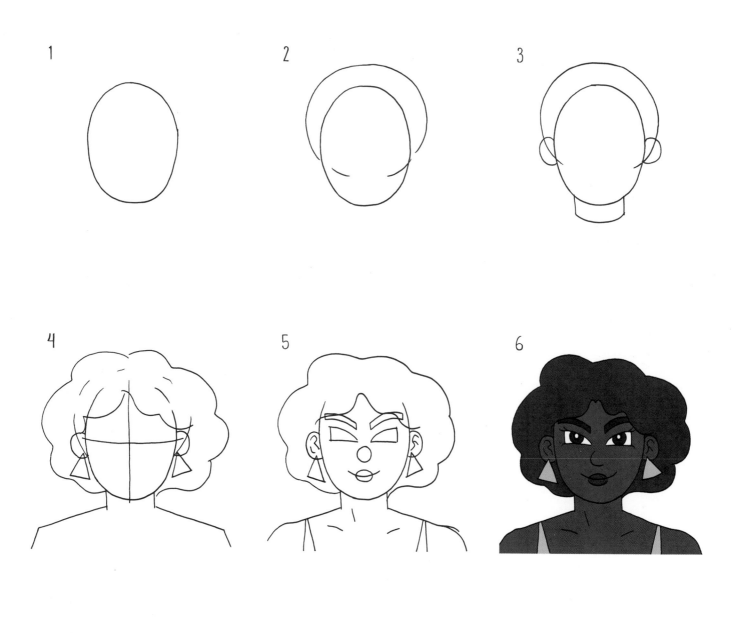

Example 2

Start by sketching a rectangle and overlapping it with a large oval divided in half. Next, add a pair of semicircular ears and a short neck. Then define the hair using wavy lines, add a jacket collar made up of triangles, and draw the shoulders. Now fill in the head with facial features. Draw oval eyes, a triangular nose, and a big oval mouth. For the last step, incorporate any more necessary details and fill the drawing with color (if desired).

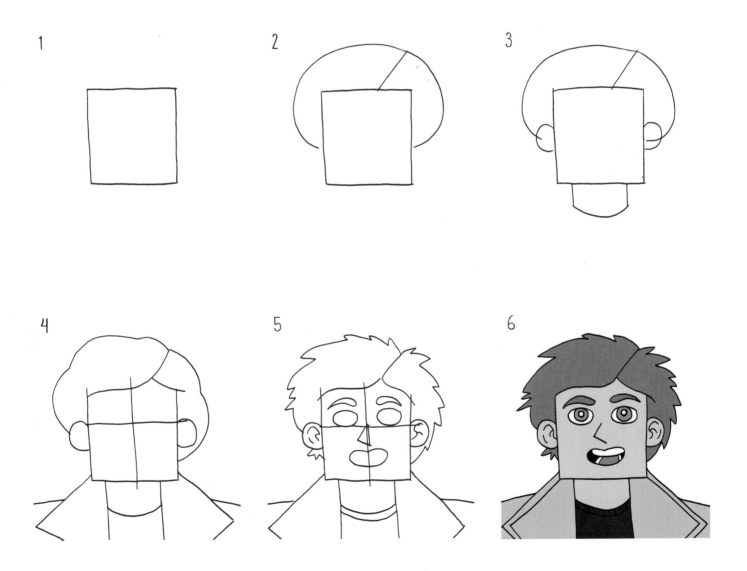

Example 3

To draw this character, begin with a circle and add a triangle to the bottom of it. Then start constructing the character's head by drawing a large arch over the top of the head, and add a pair of semicircular ears on either side of the face. Next, add a pair of triangle-shaped bangs to the forehead and draw two rectangular lapels on the jacket. Then fill in the head with the facial features. In this case, draw a pair of rectangular eyes, two rectangular brows, a triangular nose, and a simple mouth. In the last step, simply fill in any remaining details and go over the illustration with color (if desired).

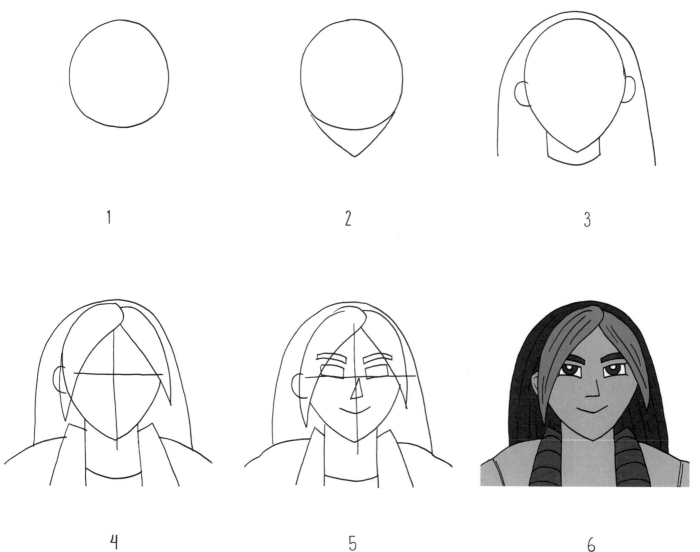

1

2

3

4

5

6

WHAT DOES CLOTHING DO?

Clothing serves many functions in real life and in cartoons. Whether you realize it or not, the garments you wear inform others of where you are, what you're doing, and even who you are.

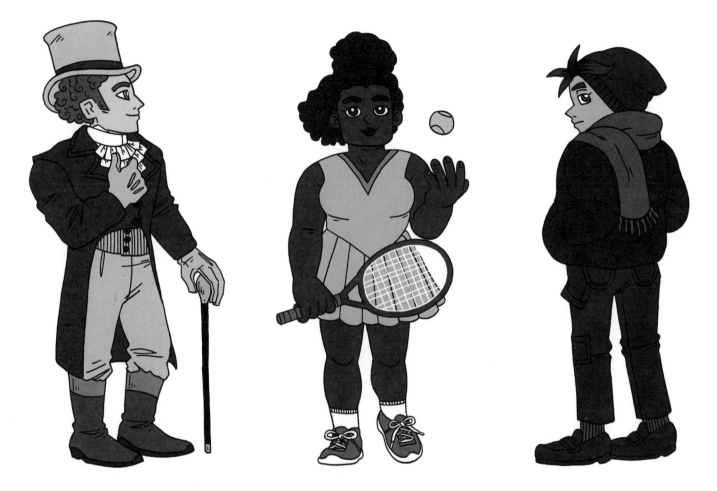

WHERE is your character?
Are they in 1700s England or 1960s America? Are they walking through the rain or lounging on a sunny beach? Clothing can help you describe the time and place that your character inhabits.

WHAT does your character do?
Additionally, clothing can convey occupation and current activity. Whether your character is a tennis pro or a banker will influence what they wear.

WHO is your character?
Likewise, the personality of your characters can also be highlighted through their personal style. Darker colors, for instance, can express a serious type of person. Likewise, a T-shirt and jeans can give the impression of a casual, low-key character.

HOW TO DRESS YOUR CHARACTER

There are two basic ways to dress a cartoon figure.

Option 1: Follow the Figure

In this approach, you will use the silhouette of your character as the guideline for the clothing. All you must do is choose the cut of the garments, such as a square neck and ankle-length pants.

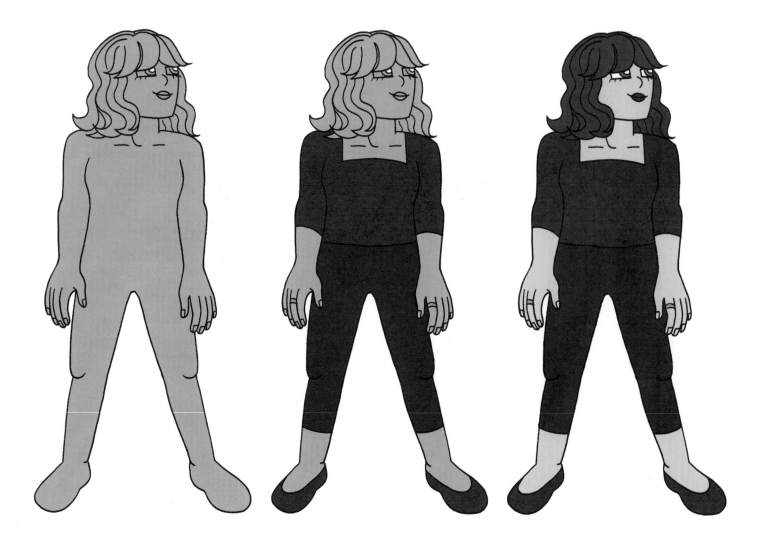

Option 2: Use Shapes

The other way to add clothing to characters is by using shapes. This technique is useful for garments that have volume, like puffed sleeves and flared pants.

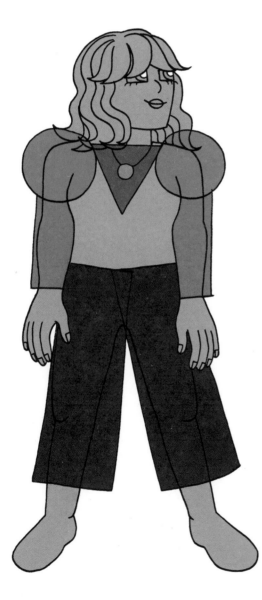
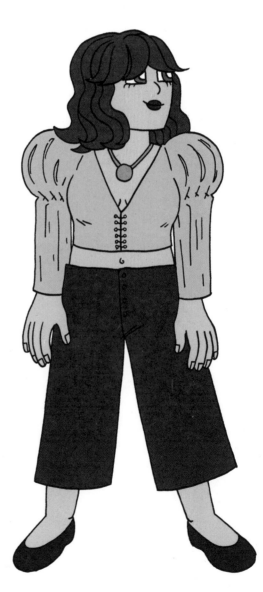

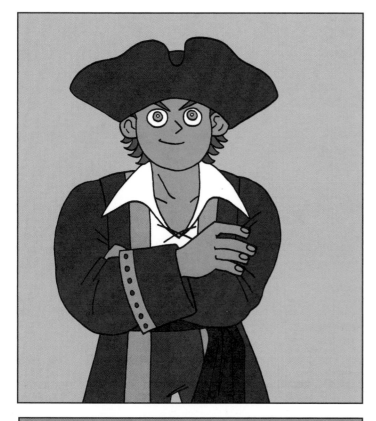

ONE CHARACTER, THREE COSTUMES

Clothing is so powerful that one character design can appear dramatically different depending on what costume you put them in. In these examples, one male character is seen in casual contemporary clothing, a pirate costume, and a referee's uniform. Each one gives you a completely different interpretation of who he is and what he's doing. See the difference?

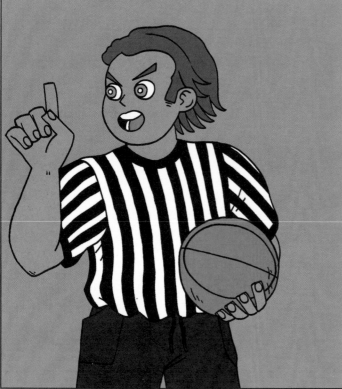

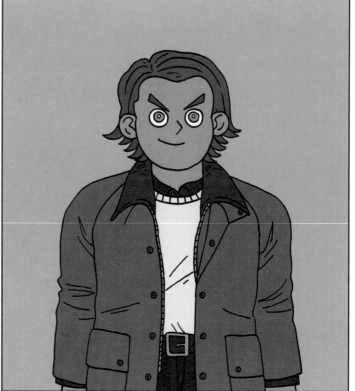

Clothing has other powers too, however. It can also highlight changes in your character, such as the transformation from ordinary to extraordinary. Cinderella, for example, receives a ball gown when she is leaving her former world for the royal one. Superheroes will shed their "normal" lives and save the day when they change into their costume.

Gallery of Portraits

By combining all these shapes, you can create a plethora of new and interesting faces. You've seen me do it in three examples, but there are many, many more faces just waiting to be drawn. Take a look around the Gallery of Portraits to see what I mean!

Want to add to the gallery? Try making your own unique face using a combination of circles, triangles, and squares, and see what you come up with.

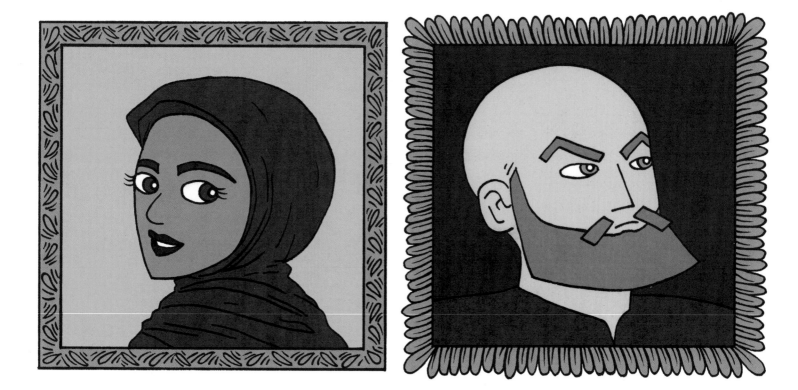

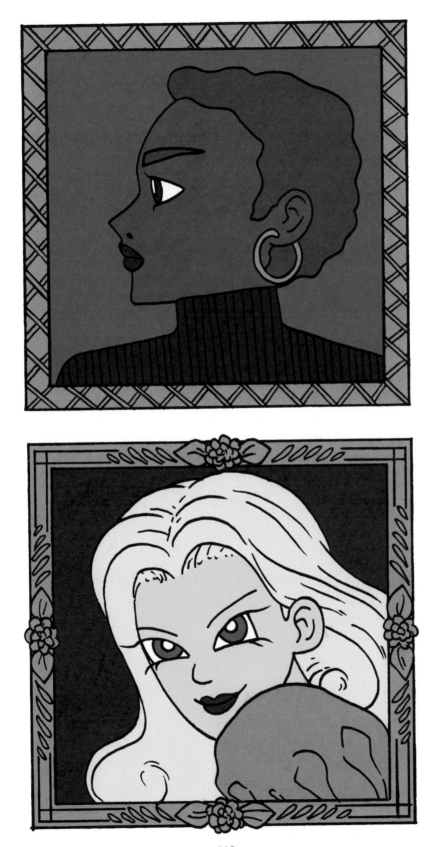

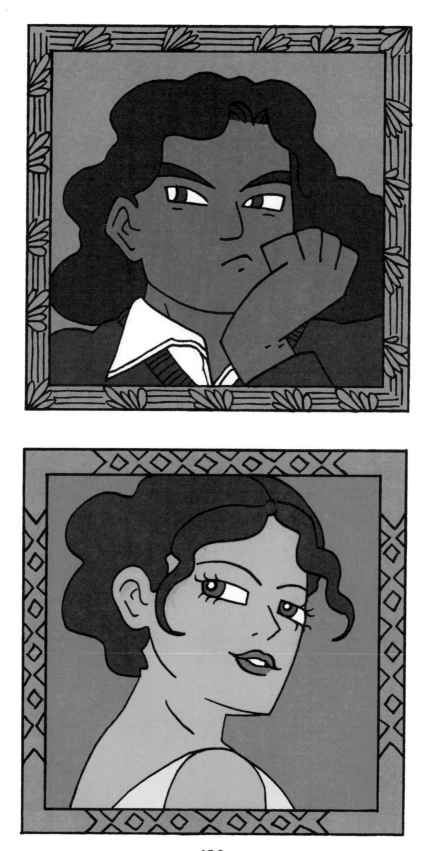

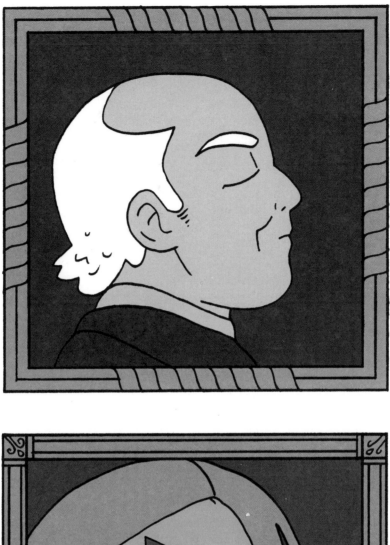

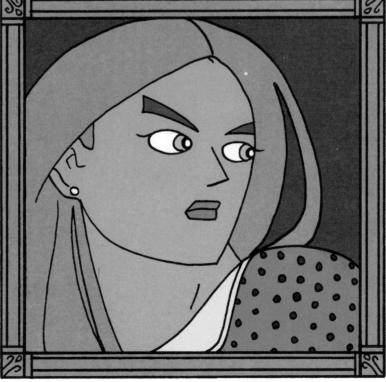

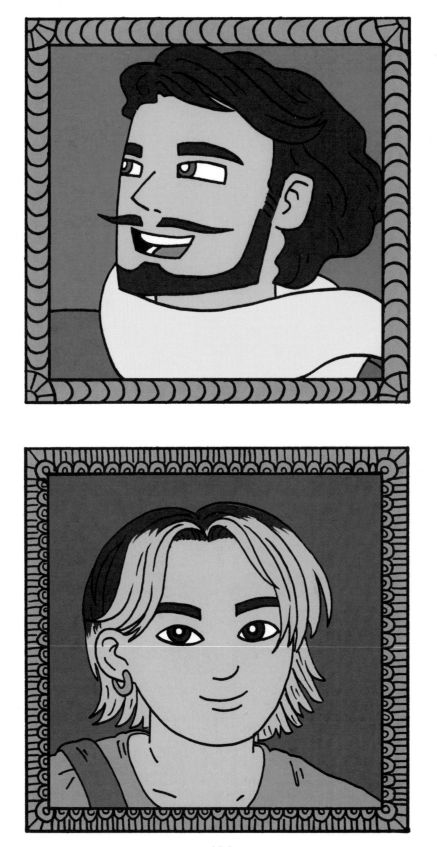

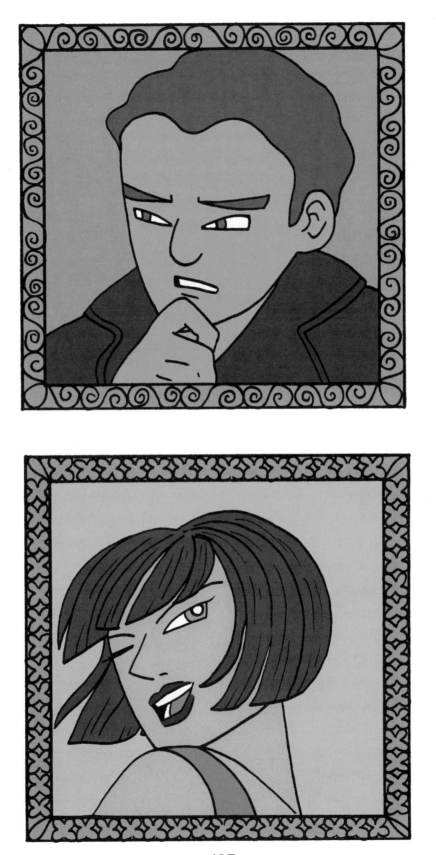

BONUS PROJECT

This project demonstrates how to draw movement...specifically, dancers! Use the shapes you've learned about throughout the book to draw this couple dancing the night away.

1

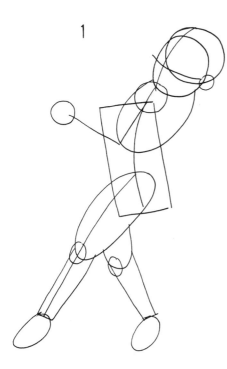

2

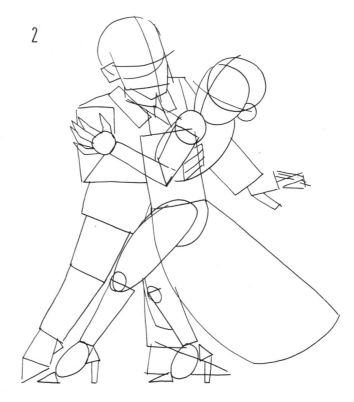

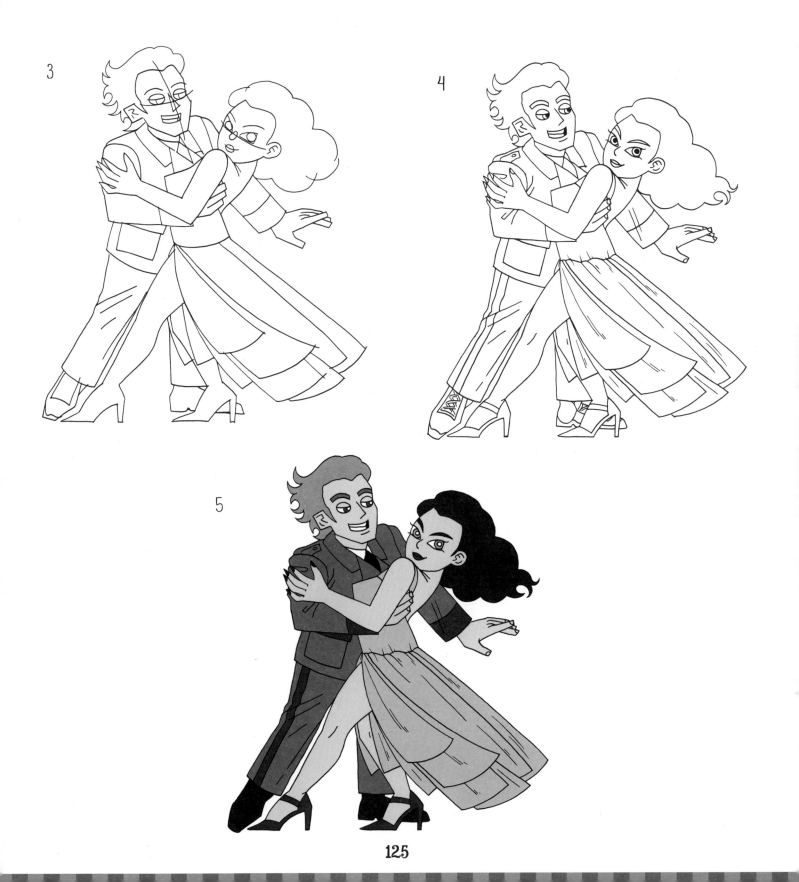